IMAGES
of America

PUTNAM COUNTY

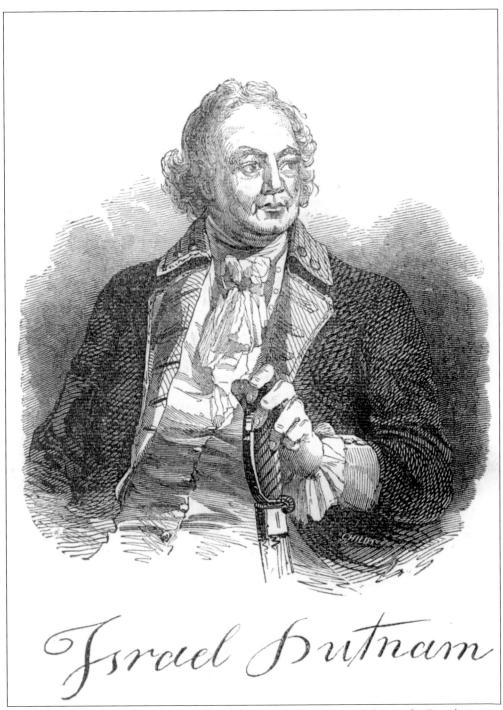

Israel Putnam

Putnam County is named in honor of Israel Putnam, a major general during the Revolutionary War and a hero in the French and Indian War. While commanding troops at the Battle of Bunker Hill, he gave the famous command, "Don't fire until you see the whites of their eyes." Putnam was born on January 7, 1718, in Salem, Massachusetts, and died on May 19, 1790. Eight states have counties named after him.

IMAGES
of America
PUTNAM COUNTY

To Laurie,

Guy Cheli

2005

Guy Cheli

ARCADIA

Copyright © 2004 by Guy Cheli
ISBN 0-7385-3656-3

First published 2004

Published by Arcadia Publishing,
Charleston SC, Chicago IL, Portsmouth NH, San Francisco CA

Printed in Great Britain

Library of Congress Catalog Card Number: 2004107305

For all general information, contact Arcadia Publishing:
Telephone 843-853-2070
Fax 843-853-0044
E-mail sales@arcadiapublishing.com
For customer service and orders:
Toll-free 1-888-313-2665

Visit us on the Internet at www.arcadiapublishing.com

For Mom and Dad.

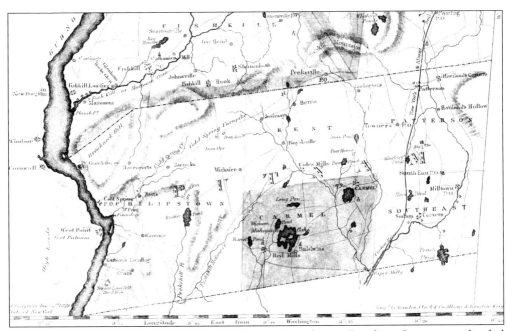

On June 12, 1812, by an act of the New York State Legislature, Dutchess County was divided
into two counties. The towns of Philipstown, Carmel, Frederick, Patterson, and Southeast were
separated from Dutchess, and Putnam County was formed.

CONTENTS

ACKNOWLEDGMENTS

I have been fortunate to be associated with the individuals listed on this page. Their contributions and assistance helped make this book a success, and they should be applauded for keeping the history of Putnam County alive. I gratefully thank and acknowledge the following: Sallie Sypher, deputy county historian; Reginald White, who expertly scanned photographs; Lillian Eberhardt, president of the town of Carmel Historical Society who met with me while the museum was closed; Betty Behr of the Kent Historical Society, who provided her personal photographs and expert knowledge and was always available for help; Emmy Oliverio, director of the Putnam Valley Historical Society who always greeted me with a smile; Donald MacDonald, Philipstown historian; Edward Adams for his great pictures; the Honorable Judge Barrett Hickman; Mike Troy for his help with photograph scanning; my good friend Albert Link Jr., who provided his personal photographs and taught me about railroads; and Amy Campanaro, director of the Southeast Museum for so willingly providing information and photograph scans. I would like to thank longtime friend and town of Kent supervisor Bil Tulipane for his great introduction. I thank my editor Pam O'Neil, and I also want to thank for their participation: John Fries, Eric Gross, Ted and Mrs. Fisher, Lynn E. Greenwood, Deborah Baldwin Van Steen, Roberta Arminio, Brendan Cornwell, Al and Diana Woermann of Dee's Antiques in Mahopac, Pete Iacovone, and Betty Iacovone.

Special recognition goes to Stephen L. Andersen, Putnam Valley town historian, who took time from his busy schedule to help me with whatever I needed. He helped clear some rough hurdles and shared his expert knowledge of the county. I especially enjoyed the guided tour of the county historic sites.

I thank Denis Castelli, who generously made his personal collection of postcards available to me. These rare and vintage postcards have been reproduced and are available from the following sources:

The Taconic Postcard Club
New York's East of Hudson Postcard Club
Susan Lane, president
P.O. Box 173
North Salem, NY 10560
E-mail: TaconicPostcard@RCN.com

Discover History at the Southeast Museum
Amy Campanaro, director
67 Main Street
Brewster, NY 10509
http://www.SoutheastMuseum.org
845-279-7500

The Alice Curtis Desmond and Hamilton Fish Library
Carol Donick, librarian
P.O. Box 265
Garrison, NY 10524
E-mail: donick@highlands.com
845-424-3020

Lastly, I thank my family—my wife, Carol, and daughters, Deana and Jillian, for much help and support.

INTRODUCTION

Putnam County has long been intimately involved in the history of the United States. In Colonial times, it was one of the prime sources of iron ore for cannons and muskets used to fight the British. The chains drawn across the Hudson River to harass the British fleets that needed to sail north were made from iron ore found in a mine in the middle of Putnam County. That mine was the target of many searches by the British army and its spies, but it was not found for the duration of the Revolution. It rests in the wooded hills of Clarence Fahnestock State Park, close to where the Appalachian Trail traverses the park en route from Maine to Georgia. On a similar note, the largest open-pit iron mine in North America existed in Putnam County until the creation of the Middle Branch of the Croton Reservoir of the New York City Watershed flooded it. The Tilly Foster Mine made a significant contribution to the economic growth of the area, and when it closed, the new iron mine area at Mesabi in Minnesota was in the beginning stages of development.

Upon learning that Danbury, Connecticut, was under attack, a Putnam County native rode to warn her father's regiment and to alert the troops to muster at his mill to save the city. Sybil Ludington rode twice as far as a certain silversmith from Boston that night, while eluding British sympathizers who were searching for her to kill her. Her effort resulted in the troops rallying and harassing the British forces south all the way to the sea. The British effort was so costly for them in terms of casualties that they never undertook a similar operation for the duration of the war.

Another vivid example of Putnam County's impact on history took place during the Civil War, when a secret effort that was as significant as the Manhattan Project occurred here. The project was so important to the outcome of the war that Pres. Abraham Lincoln secretly visited Putnam County four times to check on its progress. The parrot gun was so radically different in its design that it revolutionized cannons and was manufactured worldwide from then on. The design greatly increased range and accuracy. It was invented and produced in Cold Spring.

Today, Putnam County is a bucolic reminder of how life can be. Free from the pressures of life in a city, residents hike the trails, climb the mountains, bicycle on and off-road, and swim and fish in the lakes and streams. In a couple of locations, record fish have been caught (please do not ask me to disclose the places). For bicyclists, what remains of the route of Sybil Ludington has been marked and the gaps filled in to create the 42-mile circular Tour de Sybil. Those who follow the red square signs with the reflective white star (her horse was named Star) will gain a new appreciation of the effort involved when Sybil Ludington stepped into history.

As a validation of the values of religious freedom on which our nation was founded, the North American headquarters of the exiled Dalai Lama in Kent. The largest Buddha in the Western Hemisphere is housed here.

Guy Cheli has captured the essence of Putnam County in the text and rare vintage photographs in this volume. Putnam is fortunate to have a resident with the steady eye and the ready ear to capture and condense sights and tales of the past in an age that is guilty of focusing too much attention on the present. Read and enjoy this book and then consider a trip to Putnam.

So, come and visit Putnam County. Enjoy the many lakes, the Hudson River, and the verdant hills and parks. Come camping along the Appalachian Trail or in Fahnestock State Park. Come and enjoy the quaint villages, excellent shops, and restaurants. The newest public venture is the conversion of the old Putnam Division Railroad right of way into a rail trail that continues into the North County Trail in Westchester. Eventually, riders will be able to go from Brewster to the Bronx on a continuous bikeway.

So, come and have a look at Putnam County. You may do what most of us have done, stay!

—Bil Tulipane
Supervisor, town of Kent

One

CARMEL

The town of Carmel was formed from Frederickstown on March 17, 1795. The villages of Carmel, Mahopac, and Mahopac Falls comprise this township. Carmel was named after Mount Carmel in Lebanon because of its similar fertile and habitable valleys. Carmel is surrounded by Putnam Valley to the west, Southeast to the east, Kent to the north, and Westchester to the south. Its terrain is generally hilly, with modest valleys running in a north–south direction. The West Branch of the Croton River and Michael's Brook flow through the eastern section of town. Peekskill Hollow Brook flows through the extreme northwest corner of town. These brooks gave rise to the many mills built by the earliest settlers.

There are several large lakes here, the largest being Lake Mahopac, which will be covered in the next chapter. Lake Gilead and Lake Gleneida are two large deep lakes that are watershed properties. The West Branch and Croton Falls Reservoirs are also within the town border. The earliest known settlers in this town were believed to be the Hamblin family, who came from Cape Cod in 1739. Timothy Shaw built his home on the north shore of the lake he named Shaw's Pond c. 1742. The lake was later given the more romantic name of Lake Gleneida.

In 1812, Putnam was taken from Dutchess County and established as the 46th county of New York State. Carmel was designated as the county seat. The first county courthouse was built here in 1814. The courthouse has been enlarged over the years to its present state. The first county clerk's office was built adjacent to the courthouse in 1822.

It was not until the county buildings were erected that the village of Carmel was formed. Businesses that were associated to the county seat caused the population to increase. There were not many houses in the village prior to 1814. Carmel became a busy village after the railroad arrived in the 1880s. The dairy farming industry experienced great growth, as milk was packed in ice and sent to New York City. By the 1900s, Carmel contained a college, two newspapers, a bank, churches, schools, and a main street lined with businesses. The town continued to grow and prosper through the next century.

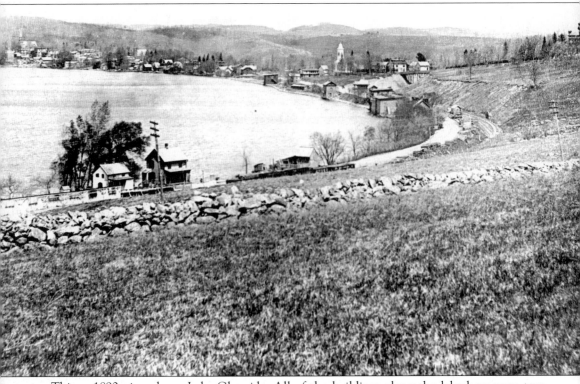

This *c.* 1890 view shows Lake Gleneida. All of the buildings along the lakeshore were torn down or razed *c.* 1895, when New York City acquired the water rights of the lake. The Drew Seminary can be seen in the upper right. (Courtesy of Carmel Historical Society.)

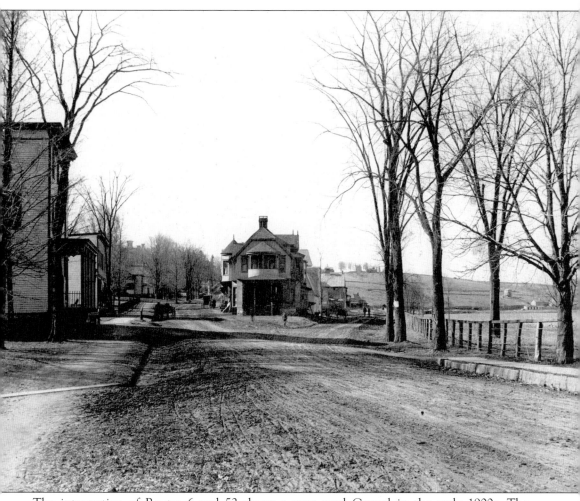

The intersection of Routes 6 and 52 shows a very rural Carmel in the early 1900s. The Charles Cole Building, Walter Schuman Building, and Robert Weeks House are pictured on the left. The Teahouse, owned by James Zickler, is in the center. The Arthur Field farm is on the distant hillside, on what is known today as Tower Road. (Courtesy of Putnam County Historian's Office.)

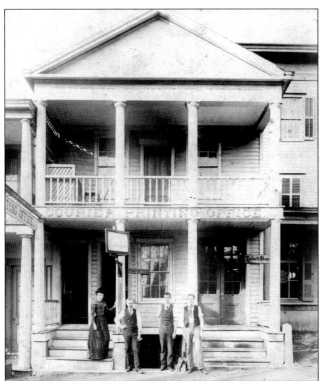

The *Putnam County Courier* Building, on Main Street, is shown here in the late 1890s. The building also housed the post office, a tailor shop, and the library. The *Putnam County Courier* is the oldest weekly newspaper in continuous circulation in New York State, dating back to 1842. It has never missed a printing, even after a fire destroyed the building in the 1930s. It is currently owned by the Journal Registry Company, and the office is still located on Main Street. (Courtesy of Putnam County Historian's Office.)

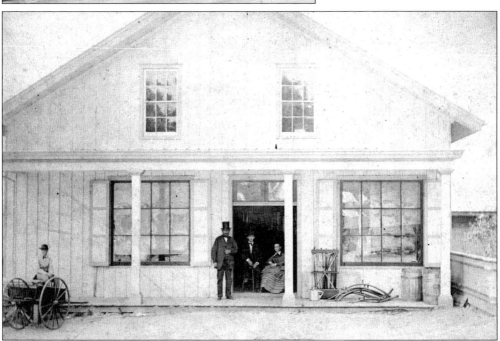

Barnabus and Horton GaNun owned this store on Gleneida Avenue. The brothers started their business in a small store on the site of the Smalley Hotel in April 1868. Horton GaNun died in 1869, and by 1877, Barnabus GaNun purchased a larger store that eventually became GaNun's Department Store. (Courtesy of Putnam County Historian's Office.)

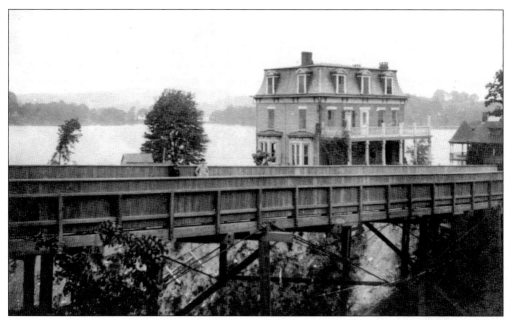

The New York and Northern Railroad (Putnam Division) passed over this wooden trestle bridge in Carmel. The bridge was built in 1871, nine years before the railroad line from Mahopac was completed. After service was discontinued, the bridge was removed and the area below was filled in. This 1890s photograph shows Lake Gleneida in the background. The house was removed from the lakeshore and placed here in 1893. (Courtesy of Putnam County Historian's Office.)

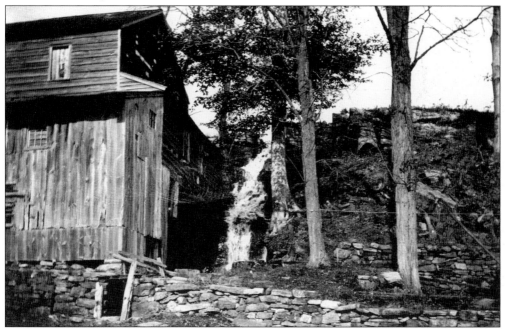

This c. 1900 photograph shows a mill believed to be Enoch Crosby's, near Lake Gilead. Enoch Crosby was an American spy during the Revolution. He is buried in the Gilead burial grounds, not far from where this mill stood. (Courtesy of Putnam County Historian's Office.)

Leo Smith's house was built in the mid-1800s on Seminary Hill Road, overlooking Lake Gleneida. It is pictured c. 1900. (Courtesy of Putnam County Historian's Office.)

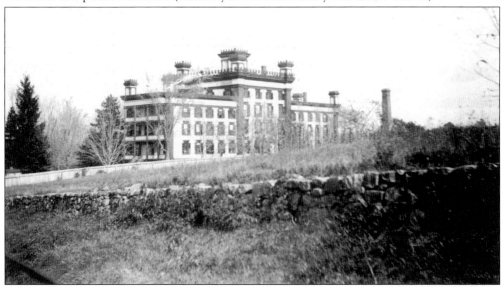

The Drew Seminary was Putnam's first college. With state and private funds, the college originated in 1850 and was called Carmel Collegiate Institute. In 1854, James Raymond donated money to complete construction of the institute. Daniel Drew bought the institute for $25,000 in 1866. The campus was thoroughly improved and renamed the Drew Ladies' Seminary. (Courtesy of Putnam County Historian's Office.)

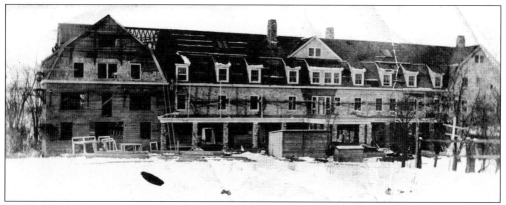

In 1904, the Drew Seminary was rebuilt after fire destroyed the original school. The college operated until the early 1950s, when it was sold to Guideposts, the headquarters of Dr. Norman Vincent Peale's magazine of the same name. This image shows the seminary under construction after the fire. (Courtesy of Putnam County Historian's Office.)

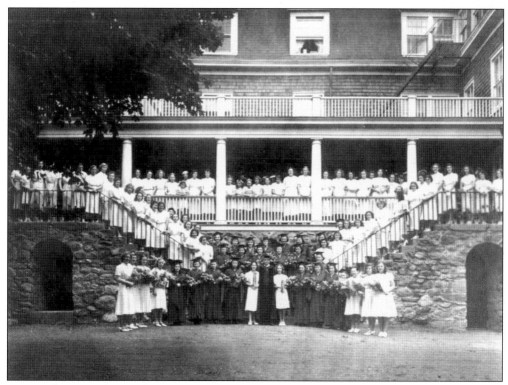

During the 1870s, men briefly attended the Drew Seminary for theological studies. The women's college offered classes of study in elementary, academic, and collegiate courses and had departments in art and music. Graduation day, a joyous occasion, is seen here in this 1930s photograph. (Courtesy of Putnam County Historian's Office.)

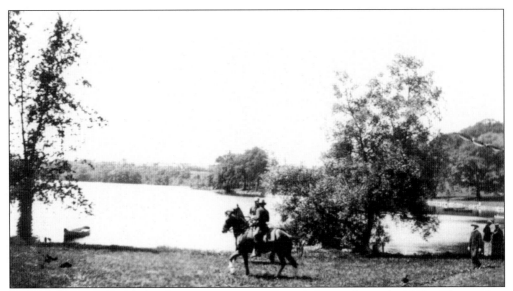

Horseback was still a mode of transportation in Carmel during the early 1900s. These riders enjoy a peaceful day near Lake Gleneida with a group of friends. (Courtesy of Putnam County Historian's Office.)

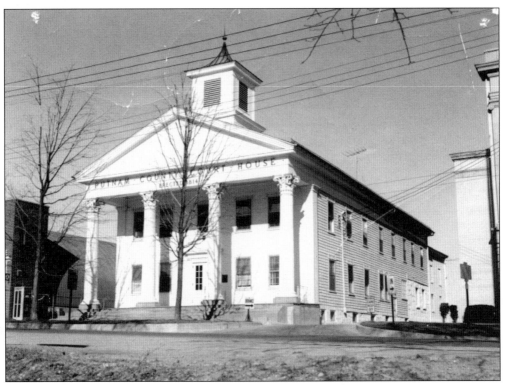

The Putnam County Courthouse was built in 1814, and the first session was held on February 15, 1815. Court was held at the Mount Carmel Baptist Church between 1812 and 1814. This is the second oldest working courthouse in New York State. (Courtesy of Putnam County Historian's Office.)

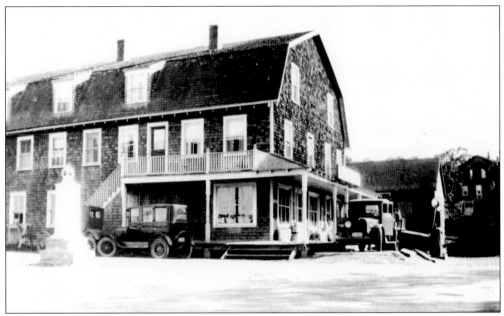

Samuel J. Hickman bought this store from his uncle Samuel Barrett in 1922. Barrett was a judge in Kent during the 1840s. He had a general store in Farmer's Mills until the property was taken over by New York City for the watershed. He moved his business to this site on Route 6 and Church Street c. 1895. (Courtesy of Putnam County Historian's Office.)

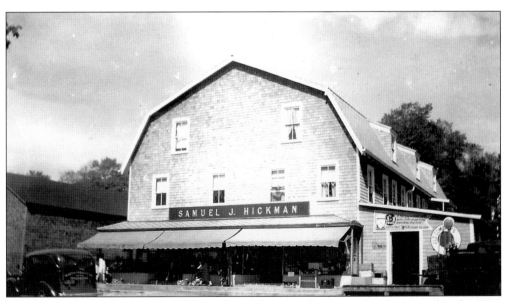

This structure, seen here in the 1930s, replaced the store that burned to the ground in the 1908 fire that consumed the entire south end of Carmel. Cinders from a steamroller used to pave the road blew onto a rooftop, and the fire quickly spread because of the windy conditions that prevailed that day. (Courtesy of Edward Adams.)

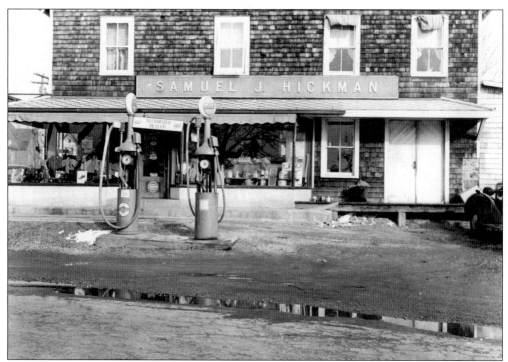

Samuel Hickman's son, Supreme Court Justice Barrett Hickman, remembers, "You could get just about anything you needed," in his father's store. Coal was delivered to local residents, and feed was delivered to the many farms in the area during the 1930s and 1940s. Gasoline was sold here until World War II. The town designated the area as Hickman's Corner after Hickman retired in 1972. (Courtesy of Putnam County Historian's Office.)

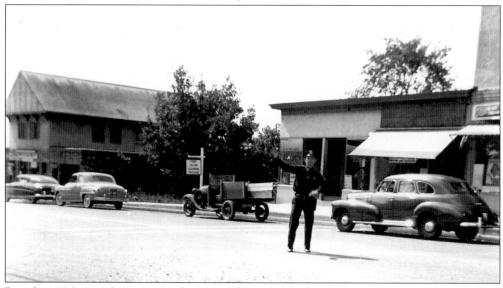

Patrolman Morgan Seymour Sr. directs traffic on Gleneida Avenue on September 21, 1949. Seymour was the very first policeman hired by the town and had the honor of wearing badge No. 1. He used his own vehicle in the early days before a patrol car was supplied by the town. (Courtesy of Frank B. Light.)

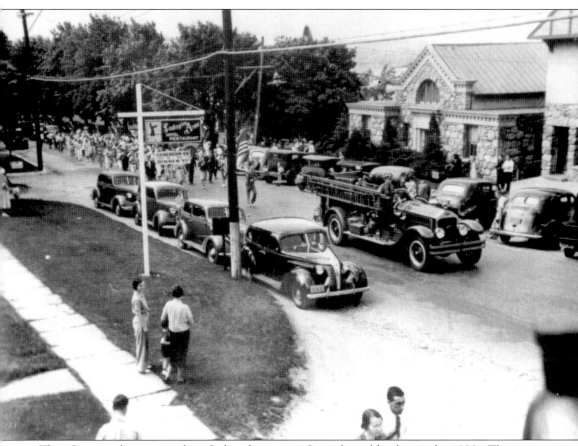

This photograph gives an idea of what downtown Carmel was like during the 1930s. The area was still quite rural, and a parade on Main Street was an event. The Putnam County National Bank can be seen on the far side of the road. The sign on the roadside states that one could get lunch for 65¢ and dinner for $1 at the Ludington Arms Hotel and Restaurant. Among other businesses and buildings along Main Street (not shown) were the Palmer Agency, which sold real estate and insurance; the two-story Shrive Building; Cliff's Garage, formerly the Carmel Taxi, owned by Dudley Adams; and the Smalley Inn. (Courtesy of Putnam County Historian's Office.)

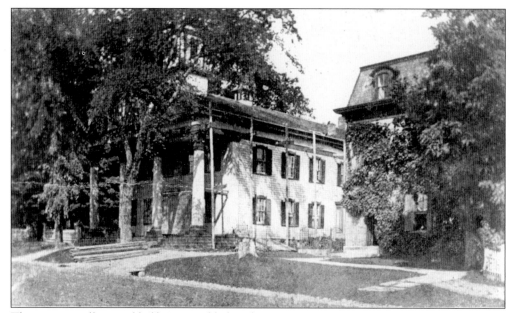

The portico, pillars, and belfry were added to the Putnam County Courthouse in 1840. A small jail was located behind the courthouse until 1855, when the current jail was built. There was one execution in the county. A crowd of 4,000 spectators gathered on July 26, 1844, to witness the hanging of George Denny, who was convicted of the shotgun murder of an 80-year-old man in Cold Spring. (Courtesy of Putnam County Historian's Office.)

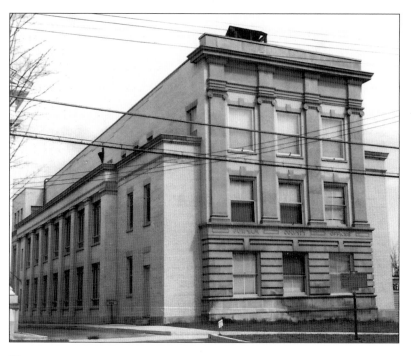

The Putnam County Office Building, with the courthouse on the left, stands on Route 52. Built in 1871, this structure replaced the original one-story clerk's office. The building has not changed since an addition enlarged it in the late 1940s. (Courtesy of Frank B. Light.)

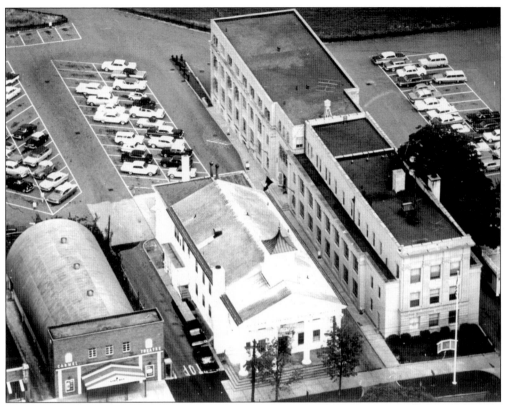

This 1960s aerial view shows buildings along Route 52. From left to right are the Carmel movie theater, in a 1940s Quonset hut, playing *The Ladies' Man*, which stars Jerry Lewis; the Putnam County Courthouse; and the Putnam County Office Building, which houses the jail. (Courtesy of Putnam County Historian's Office.)

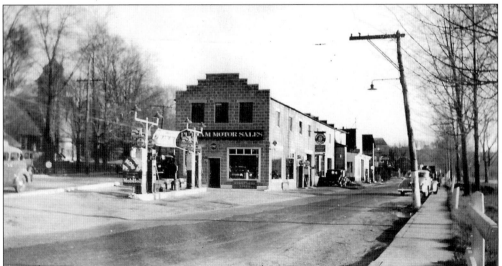

Putnam Motor Sales was at this location during the 1940s. The road on the right is Route 6, just before it turns east towards Brewster. The Gilead Presbyterian Church is visible on Seminary Field, on the left. (Courtesy of Edward Adams.)

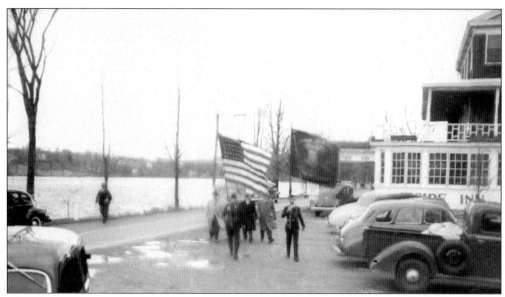

An American Legion honor guard approaches the train station next to the Lakeside Inn c. 1941. Draftees of World War II were given a ceremonial send-off before boarding a train to New York City to be inducted in the military services. (Courtesy of Carmel Historical Society.)

Thomas Townsend was postmaster from 1933 until the 1970s. He was postmaster when the first airmail letter arrived in the village of Carmel. Townsend was a volunteer airplane spotter during World War II. Civilian spotters identified planes and give their location. The observation point was on Seminary Hill. A shed was first used for spotting, but it was later replaced by a 30-foot tower. (Courtesy of Willitt C. Jewell.)

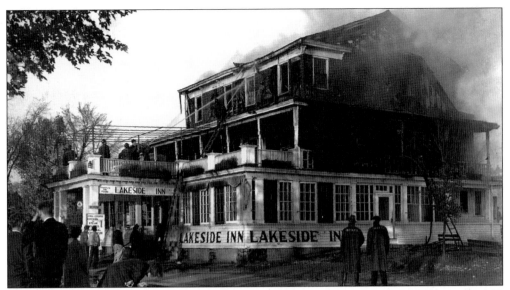

Fire claimed the Lakeside Inn in 1942, while it was owned by Patrick J. Lynch. The inn had 22 rooms, with about half the guests living there on a permanent basis. The main 40- by 60-foot section of this building is from the original Lockwood Hotel (Gleneida House), built on the shores of Lake Gleneida in 1850. When the city of New York purchased the lake, the building was moved across the road and about a half a mile south. After several owners, it was purchased by John H. Mealey and Park A. Mahoney *c.* 1911, by Patrick Lynch in 1930, and by William Shilling, who owned it until the late 1980s. Today, it is the Hunan Empire Restaurant. (Courtesy of Carmel Historical Society.)

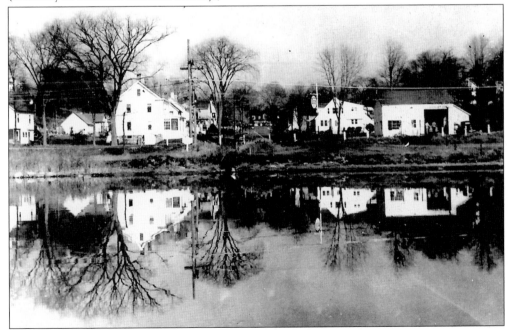

This unique view of Fowler Avenue was taken from a boat on Lake Gleneida in the 1940s. Before the days of refrigeration, local dairies stored milk in the cold depths of the lake. The milk was then loaded onto railroad cars and sent to New York City. (Courtesy of Frank B. Light.)

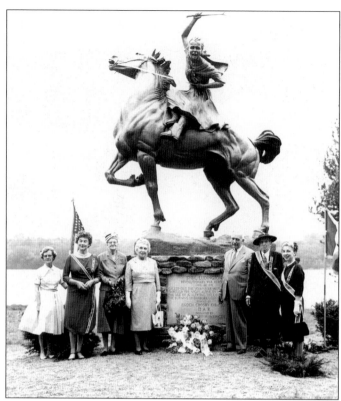

The unveiling of a station honoring Sybil Ludington took place in 1961. The statue is on the shores of Lake Gleneida at Route 52. In 1777, 16-year-old Sybil Ludington rode 40 miles through Putnam County and part of Dutchess County to call out her father's regiment to stop a British raid on New York and Connecticut. Her nighttime ride took her through enemy-occupied areas, a deed much more courageous than Paul Revere's ride. (Courtesy of Willitt C. Jewell.)

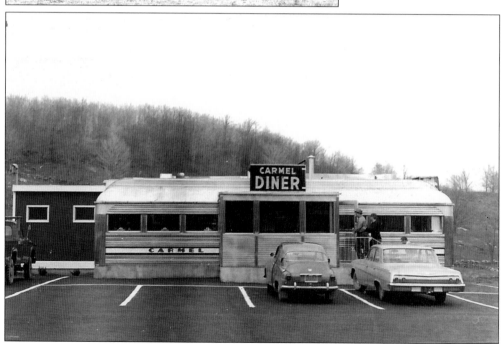

The Carmel Diner was originally located on the corner of Fair and Main Streets. It was purchased by Max Pearlman in 1948. This diner, a Silk City model, was moved north onto Route 52, near the Shop Rite Plaza, in 1967. (Courtesy of Frank B. Light.)

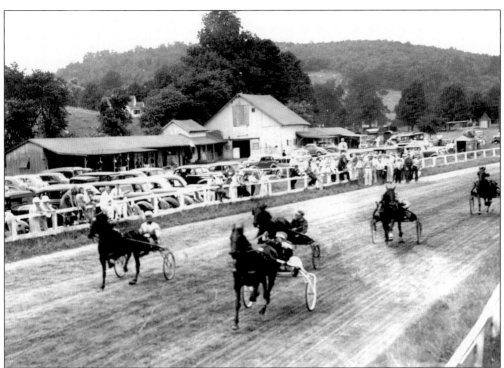

The Putnam County Fairgrounds were on Fair Street near the high school. The first fair was held on October 8, 1851, in Carmel. For a time, the fairs were held at both Brewster and Mahopac until the property on Fair Street was acquired in 1865. A half-mile racetrack was built, and horse racing was sanctioned by the Gleneida Racing Association until 1932. (Courtesy of Putnam County Historian's Office.)

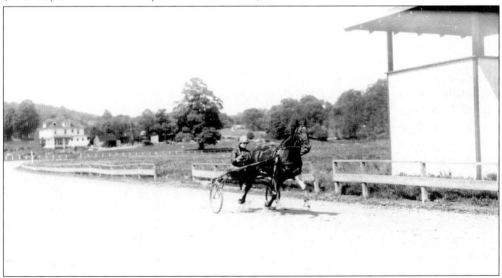

Horse racing became very popular in Carmel during the early 1930s. There was interest in building a permanent racetrack, but plans ceased because of the racetrack that had been built in Yonkers. The building in the background was used to display livestock and produce. (Courtesy of Putnam County Historian's Office.)

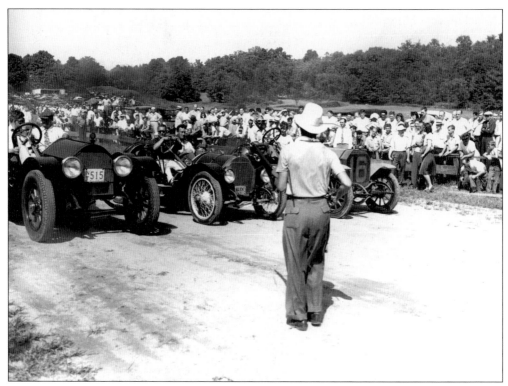

The purpose of the Putnam County Fair was to exhibit prize livestock and produce. With the decline of farming in the area, interest waned. Antique automobile racing was introduced in the 1940s in hopes of boosting attendance. (Courtesy of Putnam County Historian's Office.)

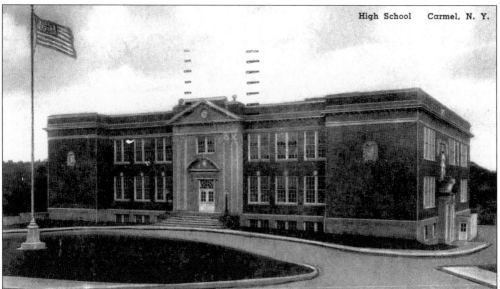

High School Carmel, N. Y.

Carmel High School was built on Fair Street in 1930. The school, as seen here in 1953, cost $300,000 to complete. The old school, located on Route 6 heading toward the present-day Putnam Plaza, was established in the 1890s.

Carmel resident Morgan Seymour Jr. proudly displays his trophy catch on April 1, 1939, opening day of trout season. Putnam County was then, and continues to be, prime hunting and fishing territory. (Courtesy of Willitt C. Jewell.)

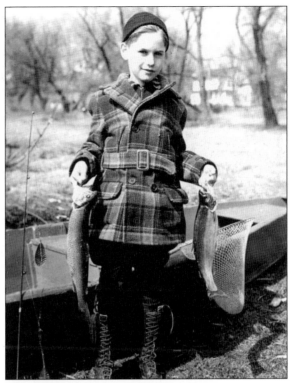

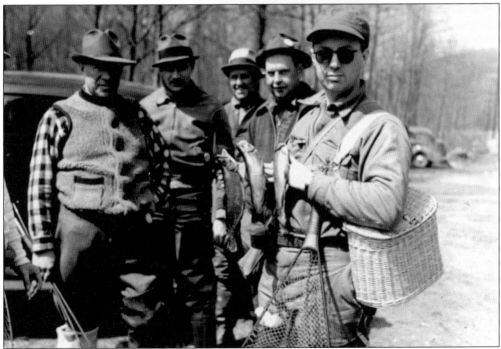

The opening of trout and hunting seasons are anticipated by area outdoorsmen. This group of fishermen poses on opening day of trout season in 1939. The men were fishing at Boyd's Brook in Kent. (Courtesy of Willitt C. Jewell.)

The east end of the upper causeway was constructed across Reservoir D after Hamilton Townsend put up the new guardrail on April 25, 1937. This reservoir has a capacity of eight billion gallons of water. (Courtesy of Edward Adams.)

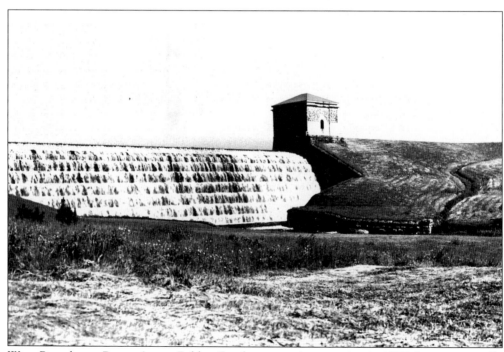

West Branch, on Route 6 near Belden Road, was put into service in 1895. It was originally called Reservoir D. The Carver farm lies beneath these waters. On the far side of this reservoir, stands Carver Mountain. The mountain was named after the Barnabus Carver family.

28

Horses Pete and Molly pull a farm wagon on unpaved Ridge Road in 1943. Dave Bennett was a local farmer who hired out his team of horses for various jobs. The town hired his team for the snowplowing of local roads. Bennett is seen here with his grandson Lynn Greenwood, a lifelong Carmel resident who writes a popular outdoor column for the *Putnam County Courier*. Bennett met an untimely death when he fell from an apple tree he was pruning on Fair Street in the spring of 1944. (Courtesy of Lynn Greenwood.)

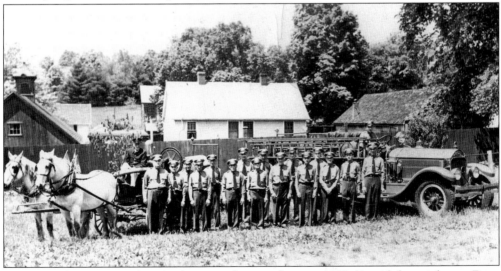

The Carmel Fire Department is shown in dress uniform in 1937. From left to right are Dave Bennett, Willis Ryder (chief), William Goehry (assistant chief), Jack Cook, John Dineen, Ky Smith, Howard O'Dell, William Kemp, Hillar Barrett, Frank Lynch, Herbert Able, Corny Kemp, William O'Brien, Lenny Norris, Percy Snelling (former chief), Birdsal O'Dell, Leo Smith, and Charles Hill (captain). The truck is a 1915 horse-drawn Buckeye pumper, the first apparatus used when the department was established in 1915. A 1929 American LaFrance is seen on the right. (Courtesy of Lynn Greenwood.)

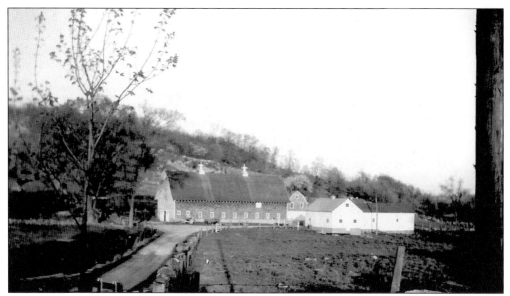

Louis Nichols bought this 110-acre dairy farm in 1929. He kept 50 head of milk-producing cows here. He also bought and sold beef cattle. A 20-acre portion of the farm was sold to the Big V Corporation for the Shop Rite store in the 1980s. The remaining property was sold in the 1990s. (Courtesy of Edward Adams.)

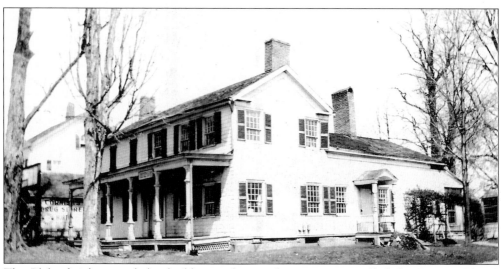

The Blake family owned this building and printed a newspaper called the *Putnam County Republican* starting c. 1880. William Blake was the author of a rare and valuable book written about the history of Putnam County in the 1840s. The shop was next to Stanley Cornish's drugstore, on Route 52. Putnam Motor Sales eventually bought the property and tore down the house to make way for its showroom. (Courtesy of Edward Adams.)

30

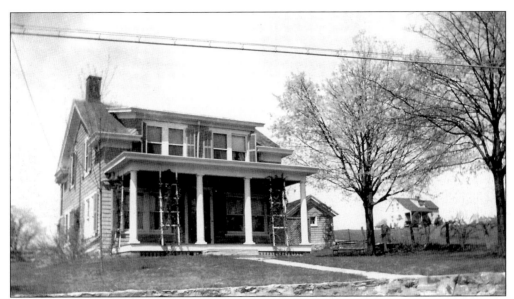

The Smalley Dairy Farm was on the corner of Horsepound and Nichols Roads. The farmhouse in this picture replaced a building that served as a stagecoach stop. Horsepound Road was an important route to Dutchess County in the 1800s, before the rails arrived. The coach stopped here, and passengers could refresh themselves and have a wholesome meal. (Courtesy of Edward Adams.)

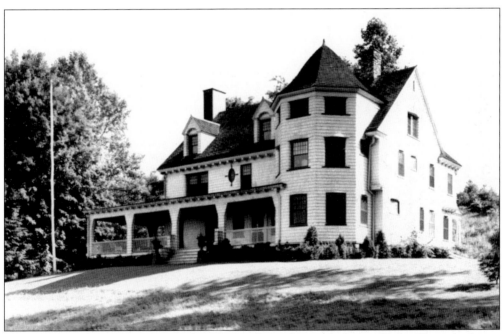

This house, built between 1800 and 1807, stands on the south shore of Lake Gleneida. It was owned by the Best family and was later acquired by the Haverback family. It was owned by the Catholic church until it was purchased by the Burchetta family in 1947. The barn has been remodeled, and the Burchetta Glass Blowing Studio and Gallery now occupies that building. (Courtesy of Willitt C. Jewell.)

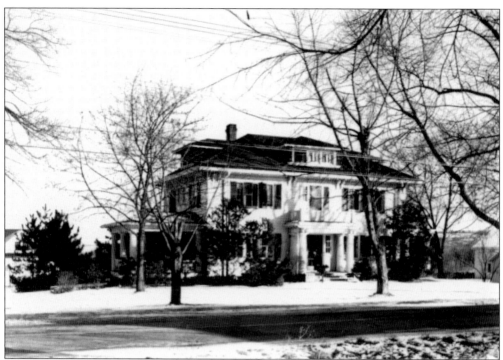

This house once stood on Gleneida Avenue, where the Carmel Fire Department is today. It was owned by a Mrs. Gilbert, who was the daughter of Dr. Barrett, a dentist in town. The residence was moved to Vink Drive in 1962, when Charles Nichols owned it. Nichols was the proprietor of Nichols Hardware Store.

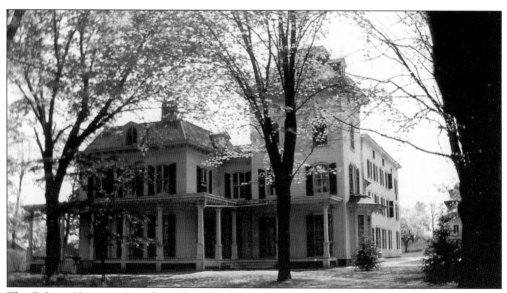

The Palmer House operated as a boardinghouse in the 1930s and 1940s. The structure dates back to the mid-1800s, when town doctor Addison Ely built it. The house on Church Street became a private residence in the 1950s, and extensive renovations have changed its appearance. (Courtesy of Edward Adams.)

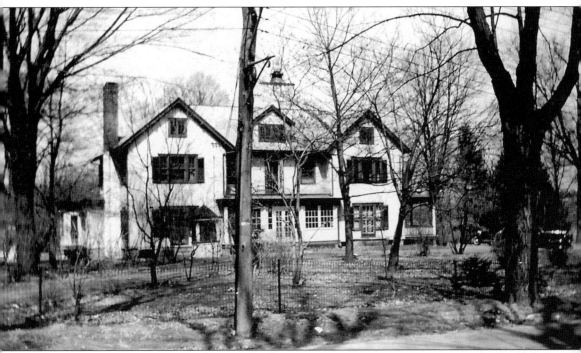

The Edward Adams Funeral Home was established on Church Street in 1964. Prior to housing the funeral home, this structure was owned by Walter Ludwig. The first Carmel phone switchboard was located here on the second floor, and the operator was Mrs. Jewell. (Courtesy of Edward Adams.)

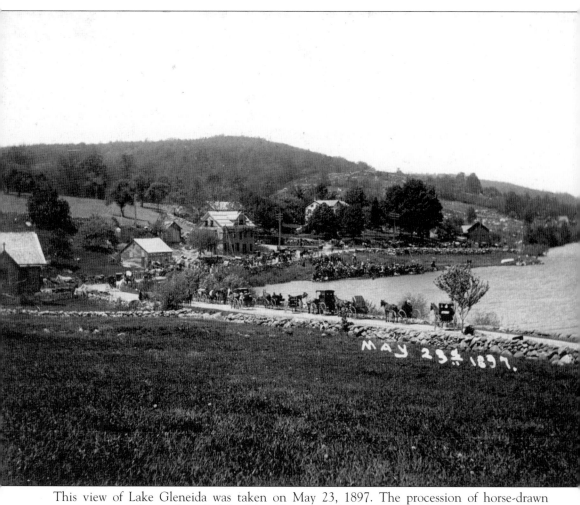

This view of Lake Gleneida was taken on May 23, 1897. The procession of horse-drawn carriages passes the south end of the lake. (Courtesy of Earnest Ballard.)

Two

MAHOPAC

Mahopac is a village within the town of Carmel. Lake Mahopac, without question, was and continues to be the centerpiece of this village and Putnam County. Earliest records refer to the lake as Big Pond. By 1740, when Robert Hughson came and settled on the north shore, it was known as Hughson's Pond. It eventually was called Mahopac Pond. *Mahopac* is a Native American phrase meaning "Great Lake." After the Revolution, the land around the lake was confiscated and sold off as farms. By the early 1800s, these large farms had been divided into smaller plots. The owners of these parcels built nice substantial villas and country summer homes here. In 1834, Stephen Monk bought an acre of land on what was to be East Lake Boulevard. On this acre, Monk built the first boardinghouse on Lake Mahopac, calling it the Mahopac Hotel.

After the Harlem Railroad was built to Croton Falls in 1849, the route to Mahopac became more accessible. With the arrival of the railroad, the hotel and tourist business boomed. The highway between Croton Falls and Lake Mahopac was so heavily used that it had to be straightened and widened. It became one of the best roads in Putnam. The first of many splendid hotels was the Gregory House, which was built in 1853 on the site of the original Mahopac Hotel. As the 1800s progressed, more hotels were built. One was more lavish and ornate than the next. Mahopac was the destination of the rich and famous, and as a resort, it was on par with Newport or Saratoga. In 1871, the Harlem Railroad Company extended a line directly to Mahopac, and a short time later, the New York and Northern Railroad had a station at Mahopac. On July 4, 1871, the first train arrived in Mahopac. A huge celebration was held in conjunction with this event. The Lake Mahopac Improvement Company planned extensive improvements to the lake area. On this day, the boulevard on the north and west sides of the lake were opened, making it possible to drive around the entire lake. The company had plans to purchase property and develop Mahopac as a cultural center with a museum and a musical arts college. After the panic of 1873 the company folded, but Mahopac continued to prosper.

By the beginning of the 20th century, Mahopac was at the absolute height of popularity as a resort. The grand hotels, some holding as many as 400 guests, were full all summer. Steamboats sailed the lake, bands played concerts, and dances graced hotel ballrooms. Many of these wooden structures caught fire and burned. Some were rebuilt, but some were not. By the 1960s, the grand hotels fell victim to the bulldozers and more profitable residential developments. The last hotel, the Forest House, was razed in the 1980s.

The actual village of Mahopac was situated on Croton Falls Road and McAlpine Avenue. The village was condemned because it was too close to a stream that fed a reservoir. It was burned down and a new village was built a short distance up the hill. The building of this village was financed by Gen. Edwin A. McAlpine. In later years, the village was shifted to its current site on Route 6N.

Mahopac Falls was primarily a farming community. This area became populated because of the Red Mills. Water flowed in the stream from Lake Mahopac and spilled over the dam at Red Mills, giving rise to the name of Mahopac Falls. In 1879, the Mahopac Mines opened on Hill Street near Stocum Avenue. As many as 150 men harvested iron ore here. In 1884, the Mahopac Iron Ore Company built a four-mile railroad line to Baldwin Place to facilitate the shipping of ore to Pennsylvania. The mine operated successfully until a cave-in in 1890s caused it to close. Today, Mahopac is a residential area with the commercial corridors being Routes 6 and 6N.

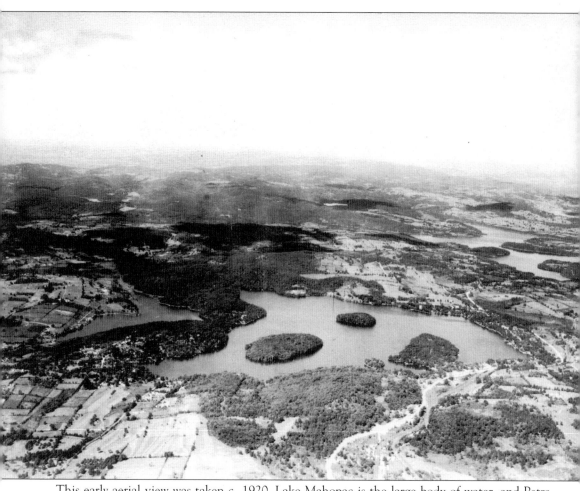

This early aerial view was taken c. 1920. Lake Mahopac is the large body of water, and Petra and Canopus Islands and Mahopac Point are clearly visible. Kirk Lake is on the left. The land between the two lakes was called Interlaken Park. The West Branch Reservoir can be seen in the distance. (Courtesy of Willitt C. Jewell.)

This view of the Mahopac Railroad station was taken in 1885. The steam engine on the New York City and Northern Railroad (Putnam Line) crosses Croton Falls Road, before it was paved. The white church, on the left, is the first Roman Catholic church of Mahopac, located on Route 6, south of Mud Pond. The building on the extreme left behind the trees is Gumpert's Putnam House Hotel, a wild place that had a shady reputation. (Courtesy of Carmel Historical Society.)

A stagecoach carried these travelers from Carmel to Mahopac in the 1890s. The road that linked Mahopac and Carmel was called Carmel Road. The road followed where East Lake Boulevard is today and continued on to Route 6. (Courtesy of Putnam County Historian's Office.)

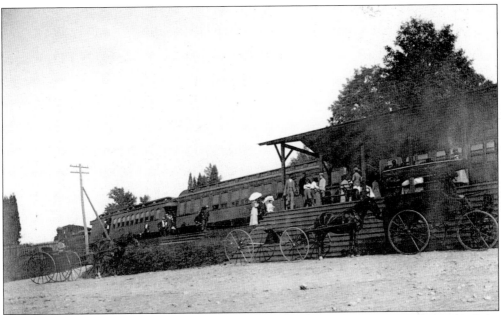

This stop on the New York City and Northern Railroad (Putnam Division) was the Lake Mahopac station. It was also referred to as the Thompson House station because it was literally steps away from the resort hotel of the same name. Passengers and guests are seen in this 1891 photograph. The American Legion Post is housed in the old train station today. (Courtesy of Putnam County Historian's Office.)

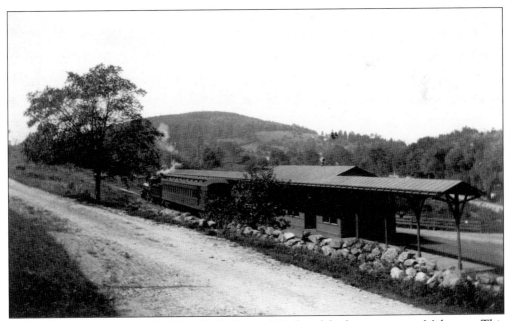

The Harlem Division of the New York Central Railroad had a station in Mahopac. This stub end station was adjacent to the Putnam station, but a few feet lower. The Harlem Line approached Mahopac from the east on a branch out of Golden's Bridge. (Courtesy of Putnam County Historian's Office.)

THE NEW YORK CENTRAL & HUDSON RIVER RAILROAD CO.

Office of the SUPERINTENDENT,

Hudson River and Harlem Divisions,

GRAND CENTRAL DEPOT.

CHAS. M. BISSEL,
Superintendent.

New York, *January 9th* 1883.

Mr. Clark
Condr. Lake Mahopac.

Dear Sir:—

We have a deduction from the Post Office, for failure of mails to arrive on route 6023 which is the Mahopac Division. They failed to arrive at G. Bridge Oct. 18th, 19th 20th & 31st and to depart Oct. 16th, 17th, 18th, 19th and 30th 1882. Was this the time of the heavy rains in Oct. and was that the cause of the delay? Please see if you can get any information which will help me to know whether their claim is correct or not

Truly yours
C. M. Bissell
Supt
Leonard

Mail was moved across the country by railroad beginning in the mid-1800s. The importance of adhering to a strict schedule is evident in this inquiry from the superintendent of the New York Central and Hudson River Railroad Company, dated January 9, 1883. (Courtesy of Carmel Historical Society.)

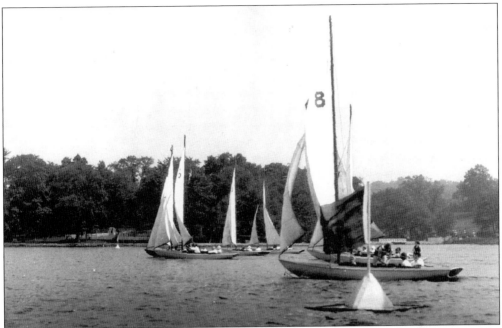

Yacht racing on Lake Mahopac was at its peak in the 1920s. The yachting season ran from the Fourth of July through Labor Day, with races held on the weekends. There was also a junior division for skippers less than 18 years of age. Junior races were held on Wednesdays; both girls and boys were eligible for these races. Participants of the senior division often stayed at the Lake Mahopac Club, where rooms ranged in price from $3 to $5 per night. (Courtesy of Carmel Historical Society.)

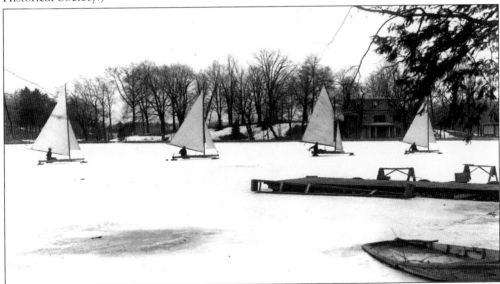

Iceboating became a popular sport during the 1930s. Mahopac resident Raymond A. Ruge built the famous bow-steering boat called the *Icicle* in 1936. He wrote articles about this sport in magazines and formed the Eastern Ice Yachting Association. He organized the Mahopac Sports Club, later renamed the White Sail Inn. An accomplished architect, he designed many of the Colonial-style homes on Lake Mahopac. (Courtesy of Carmel Historical Society.)

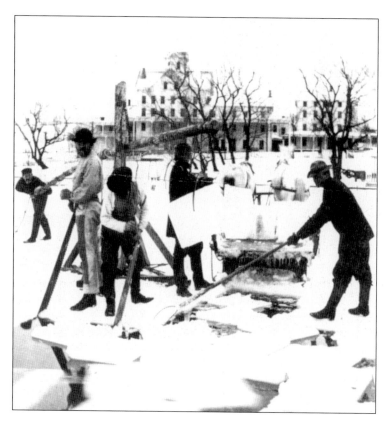

Ice harvesting was a major industry during the 1800s and early 1900s. Ice was cut from the clear fresh water of Lake Mahopac. Blocks were cut in 50- by 100-foot chunks and then cut into smaller pieces to be sent through a canal that passed under East Lake Boulevard and led to the Knickerbocker Ice House. The building, the largest in Putnam County at the time, was located just south of Croton Falls Road, on the west side of Route 6. By the 1920s and the advent of refrigeration, the business had died.

Sadie Erickson built this ice-cream parlor in 1934. The contemporary building style stood out from most structures of its time. The parlor was on the property where the present-day library is located. Waldo Erickson ran the boat livery station. Sadie Erickson left the property to the town in 1952 for the new library. Before the building was razed, local residents were invited for a final ice-cream social. (Courtesy of Carmel Historical Society.)

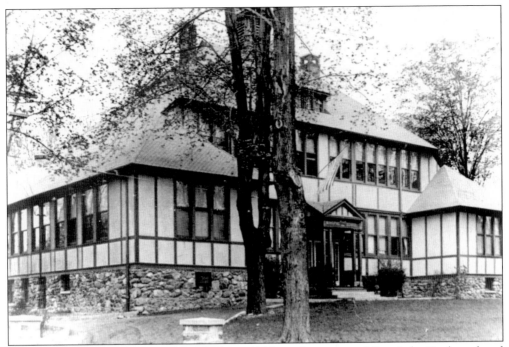

The old Mahopac High School was built in 1918 on the corner of East Lake Boulevard and Croton Falls Road. The Gregory House Hotel stood here until it burned down in 1878. The school was used until 1938, when the Lakeview High School opened. A hospital was located here until the Mahopac School District Administrative Building took over this site. (Courtesy of Willitt C. Jewell.)

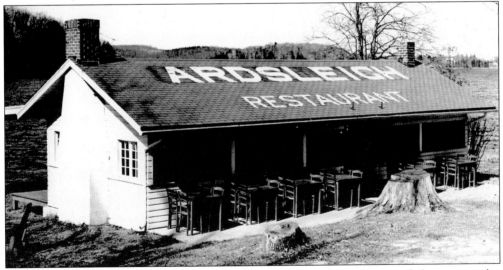

The Ardsleigh Restaurant was located on Route 6N on the property of the present-day Dockside Pub. The restaurant was owned by Grado Ardslesiean, who also built the Ardsleigh House Hotel in 1912. The hotel was across the road on a bluff, with a wonderful lake view. The small hotel contained 30 rooms. After numerous additions and renovations, this hotel burned down in 1969. The Restivio Chiropractic Office is now located on this site. (Courtesy of Carmel Historical Society.)

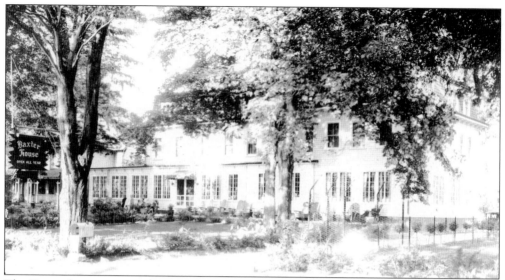

The Baxter house, as seen here *c*. the 1920s, was first called the Viault Cottage. The hotel was on East Lake Boulevard, across the road from the lake. The Baxters also owned the Baxter Teahouse, located opposite this building, on the lakefront, where Cunningham's restaurant is today. The hotel was destroyed by a fire in the 1960s and was replaced by garden-style apartments.

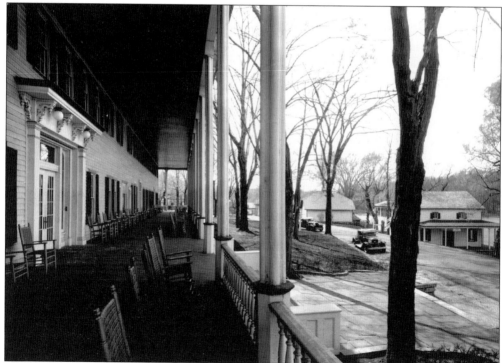

The Thompson House was built as a boardinghouse on the corner of Route 6 and East Lake Boulevard in 1851. After a series of additions, the hotel was able to accommodate 300 guests. Fire destroyed the hotel on July 6, 1869. Nathan Thompson rebuilt a much larger hotel on the same property. (Courtesy of Carmel Historical Society.)

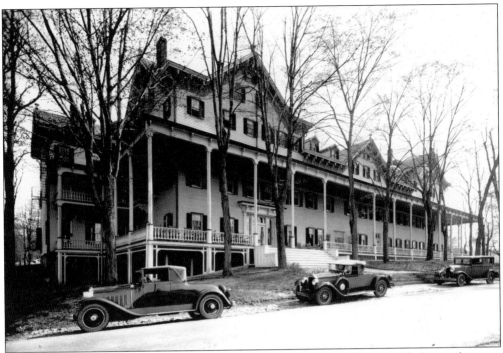

In 1883, the Thompson House was purchased by Emerson Clarke. Clarke made great improvements including a ballroom, bowling alleys, and a billiard room. By this time, the hotel could accommodate 400 guests. Eventually, the hotel was renamed the Hotel Mahopac. Movie stars Ann Sothern, Linda Darnell, and Jeanne Crain stayed at the hotel during the early 1950s. The hotel, which stood where the Four Brothers and Evolution Gym are today, was one of the finest on the lake until it was destroyed by a fire in 1964. (Courtesy of Carmel Historical Society.)

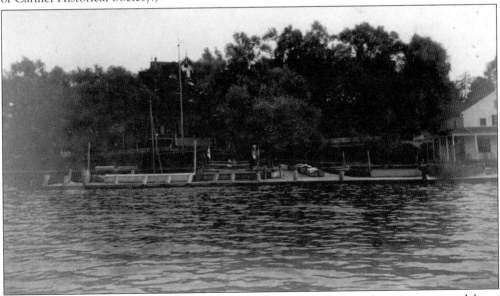

This view shows the Thompson House dock. Motorboats and rowboats were rented here. Waldo Erickson's boat livery and ice-cream shop were also located here.

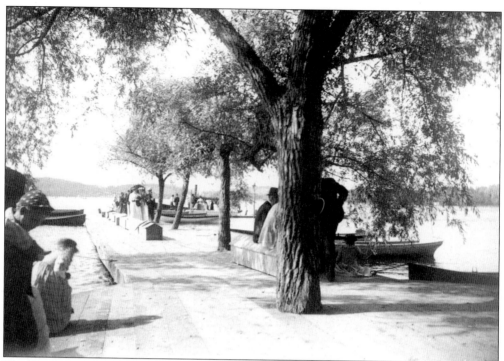

The Thompson House Hotel had a large boat dock. The guests shown here in the 1890s were waiting for a ferry to take them to the islands on the lake. The water is said to have been so clean and clear that one could see the bottom 20 feet below. (Courtesy of Putnam County Historian's Office.)

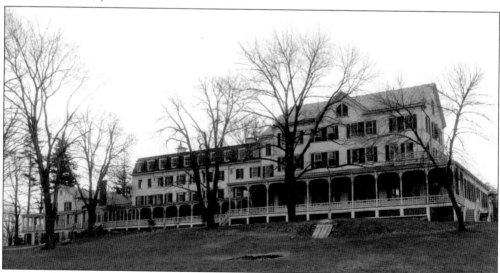

The Dean House was built by Amzi Dean in 1852. The property consisted of eight acres of gently sloped lawn on the west side of Lake Mahopac, where Route 6N and West Lake Boulevard intersect. The hotel had a nine-hole golf course on the property, where the middle school stands today. The kitchen served fresh country eggs, pure milk, cream, butter, and vegetables produced at the hotel farm. The hotel was razed in 1971, and the site is occupied today by Dean House Estates.

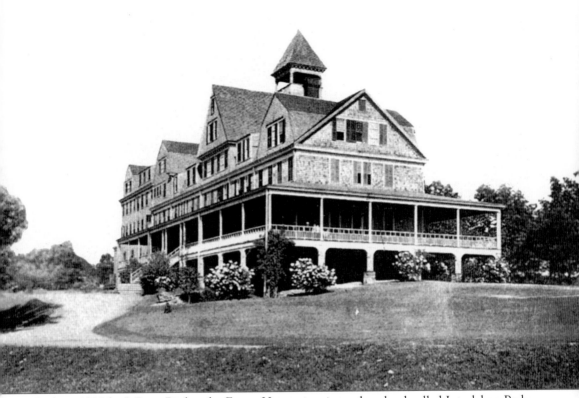

Built in 1893 by J. Prior Rorke, the Forest House was situated on land called Interlaken Park. The park was pleasantly situated between Lake Mahopac and Kirk Lake. The hotel management bragged about the fact that all of the rooms had a view of either lake. There was a series of scenic trails and walkways between the two lakes. The wood frame hotel seen here was destroyed in a fire on January 17, 1940, and was rebuilt as a brick structure. The brick hotel was eventually torn down to make way for private homes in the late 1980s.

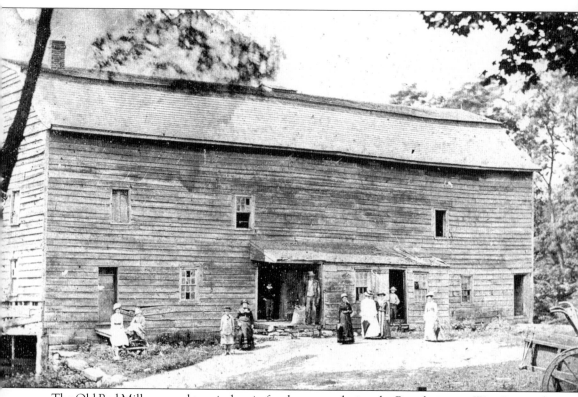

The Old Red Mill was used to grind grain for the troops during the Revolutionary War. Pictured c. the 1870s, it was built in 1756 on the corner of what is known today as Route 6N and Hill Street. The outlets of Lake Mahopac and Kirk Lake provided waterpower to run this mill and two others, a woolen carding mill and a sawmill. When the first mill was built here, in 1745, the area was called Kirkham's Mills. The later mills were built with massive timbers covered in cedar and painted red. From that time on, the area was known as the Red Mills.

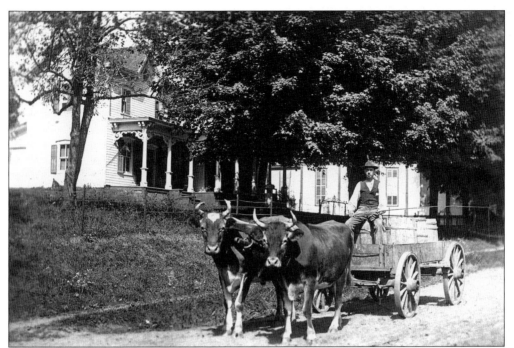

Allen G. N. Gilbert is seen with his apple wagon and pair of oxen traveling on Route 6N toward Secor Road *c.* 1900. The original Baptist church can be seen in the background. The house, on the right, still stands and has been extensively restored. This print was rescued from a building being demolished on Wood Street. Unfortunately, no others were found. (Courtesy of Carmel Historical Society.)

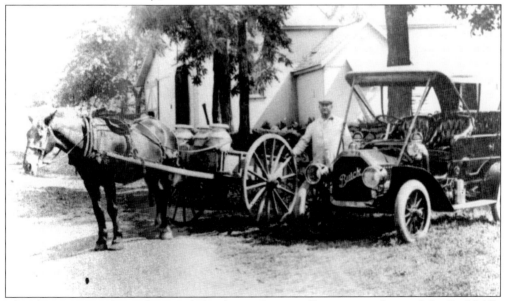

Theodore Agor is shown here with his horse-drawn milk wagon in front of the Red Mills Baptist Church *c.* 1910. A new Buick automobile provides a hint at what future technology will bring. Members of the Agor family worked as farmers and merchants, and they held several town offices. (Courtesy of Putnam County Historian's Office.)

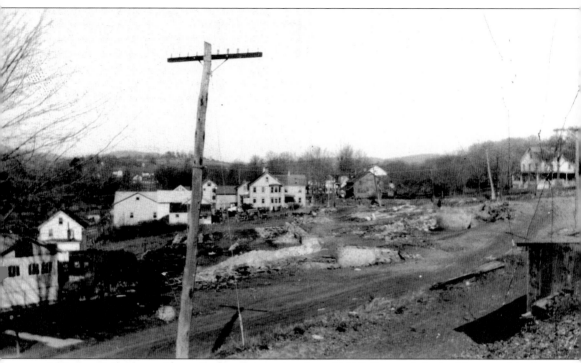

Mahopac Falls is seen here after the devastating fire of 1919. Some of the buildings on Myrtle Avenue have survived to this day. The large building on the right is the Mahopac National Bank, on Route 6N.

Students of the two-room schoolhouse at Mahopac Falls pose for this photograph c. the 1920s. From left to right, they are as follows: (first row) Tucker, Pierre Geis, Edwin Taylor, and Raymond Smith; (second row) Frances Austin, Marjorie Agor, Ethel Austin, Elsie Agor, Alice Austin, ? Osbourne, Jesse Agor, and ? Osbourne; (third row) Carol Agor, Bertha Potter, Lena Smith, and Mabel George; (fourth row) Constance Austin, Beatrice Geis, and Dorothy Head; (fifth row) Althea Adams, Thera Pinckney, and Violet Barrett; (sixth row) Frank George, Ralph Brady, and Marvin Williams. Local streets are named after the direct descendants of many of the children pictured here. (Courtesy of Carmel Historical Society.)

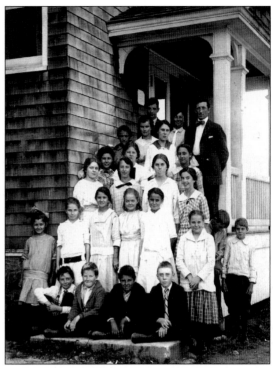

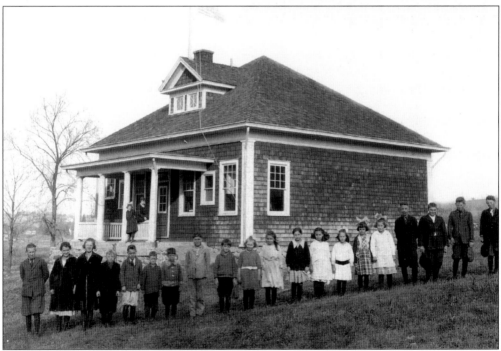

The little red schoolhouse was built on School Street in Mahopac Falls in 1854. It had between 50 and 70 students each year. The building was used as a school until 1938, when Lakeview School was opened. It was then turned over for use as a fire department. The original building still stands here and has received extensive additions. (Courtesy of Carmel Historical Society.)

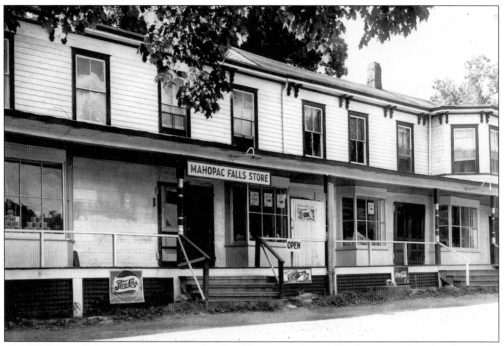

The Mahopac Falls store was owned by Gus Finger in the 1950s. Finger, a butcher by trade, operated the store as a meat market and grocery store. The second floor housed apartments. Rocco's Pizzeria now occupies the building, which remains very much the same today. (Courtesy of Carmel Historical Society.)

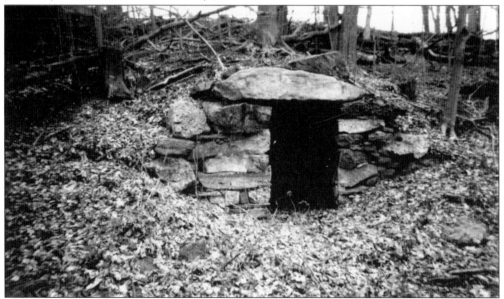

The mystery of the Stone Chambers is intriguing. There are more than 100 chambers throughout Putnam. All are built in a similar fashion. Some believe they were used by the Druids as ceremonial temples. It is known that farmers used them to store food during the 18th and 19th centuries. Many chambers are near Revolutionary War sites, and it is believed they were used to store gunpowder and arms. This chamber is located on Agor Lane in Mahopac.

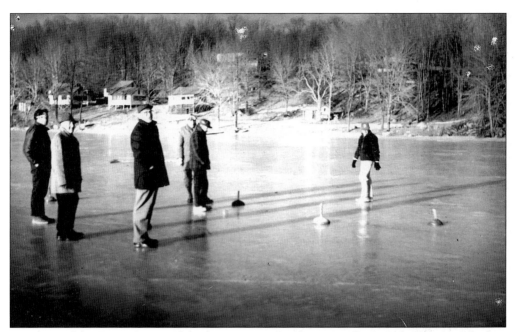

Members of the Secor Sports Club play a game of curling on a frozen Lake Secor in the late 1960s. Victor Bauer is third from left, and Bill Pfister Sr. is on the far right. The cabins on the lakeshore belong to Camp Secor. Farther up the hill was Camp Henry, which was run by the Henry Street Settlement House. The camps are gone now, as they gave way to development. The Secor Sports Club remains active today. (Courtesy of Secor Sports Club.)

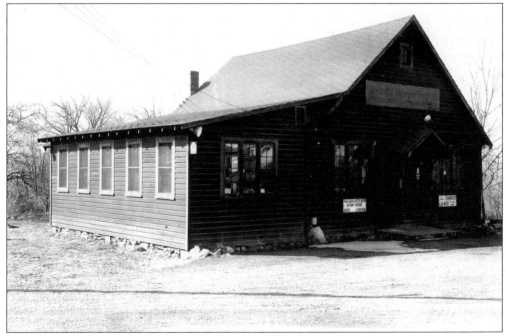

The Green Acres Tavern was a popular watering hole for the residents of Lake Secor in 1938. The establishment on Secor Road was part of 50 acres owned and subdivided by the Green family. It operates today as Pour Boy's Tavern.

53

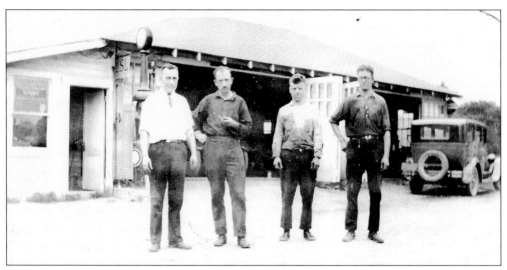

"Gene and his gang" are seen here with a Model A Ford at Lake Mahopac on September 11, 1928. As the automobile became more prevalent, the need for qualified mechanics grew, especially in the 1920s. Blacksmiths learned this trade and turned to automobile repair as a way to earn a living.

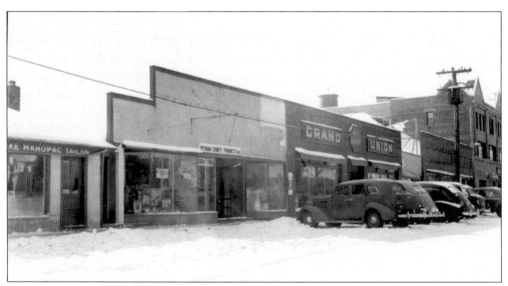

This photograph shows Main Street in the 1930s. The Lake Mahopac Tailor Shop was owned by Caesar Iacovone and has since relocated around the corner on Cherry Lane. The Grand Union moved to a site on Route 6, and the building burned in the early 1960s. The barbershop was owned by Mr. Marino. The post office was to the right of the Grand Union and eventually moved to Route 6. (Courtesy of Putnam County Historian's Office.)

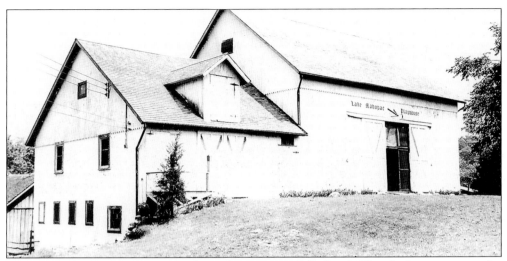

The Lake Mahopac Playhouse was located on Croton Falls Road. The playhouse was popular with local residents in the 1930s and 1940s. In addition to live stage acts, the playhouse showed motion-picture movies. (Courtesy of Albert Link Jr.)

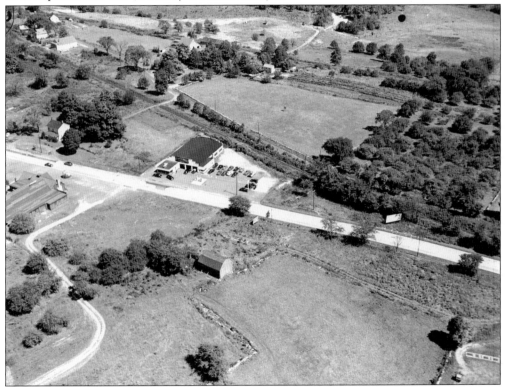

The Fisher Brothers' car dealership, owned by Donald and Hascal Fisher, is seen in the center of this 1949 image. Route 6 is the road running from left to right, and the land on either side of it is part of the Albert Agor farm. The New York City and Northern Railroad, behind the car dealership, is the bike trail today. The structure across Route 6 is the village barn, then a restaurant and bowling alley and, today, the Hudson Valley Beverage Center. The white house on the left still stands as the Ridgeview Auto Body Shop. (Courtesy of Albert Link Jr.)

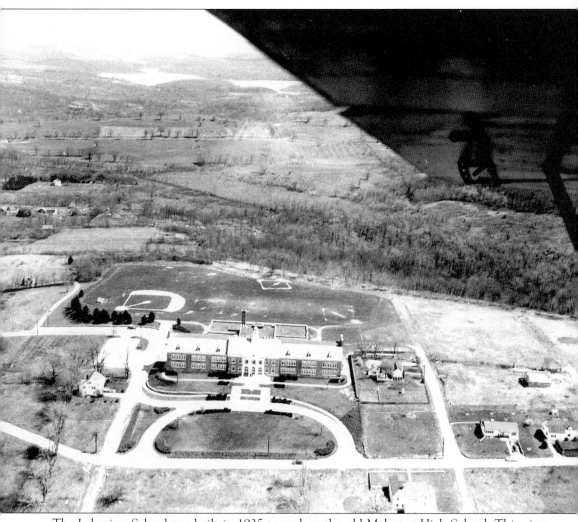

The Lakeview School was built in 1935 to replace the old Mahopac High School. This view shows how sparsely populated the area around the school was in 1949. Today, the school has a large addition and neighborhoods around it. Some of the pine trees behind the baseball diamond remain today, but the farms seen in the distance no longer exist. The area was developed in the mid-1950s. Lake Mahopac Ridge, one of the first subdivisions in Putnam, featured nicely appointed Cape and ranch-style homes. (Courtesy of Albert Link Jr.)

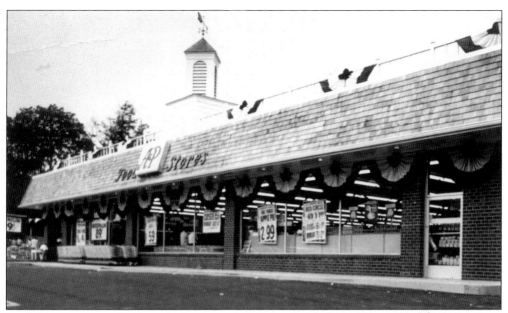

This 1960s photograph shows the A & P Food Store on Route 6. The building stood on the site of the old Thompson House Hotel. Today, the Four Brothers Pizza Inn and Restaurant and the Evolution Fitness Club are located here. The A & P closed this store in the early 1980s and moved to another Route 6 location farther south. (Courtesy of Willitt C. Jewell.)

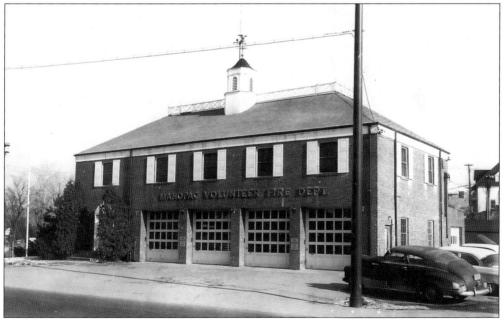

The Mahopac Firehouse was built in 1948. Department members worked two-hour shifts to be ready for the May opening. Furniture was donated by the community. American Legion Post 1080 provided chairs for the television room. The building has an assembly hall on the second floor that is made available to local organizations. Since the department formed in 1913, brave and dedicated firefighters have served the community. (Courtesy of Frank B. Light.)

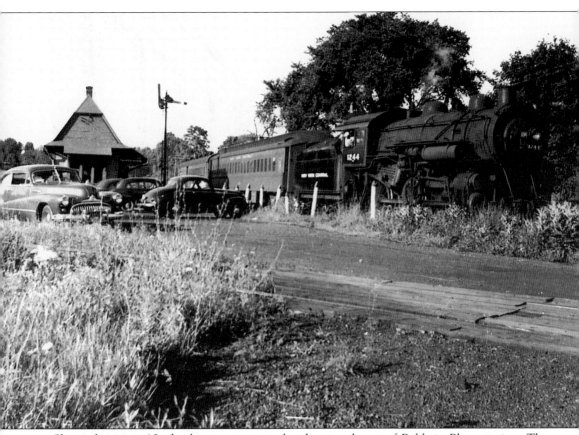

Shown here is a 10-wheeler steam engine heading south out of Baldwin Place station. The conversion of steam engines to diesel power started on July 2, 1951, in an attempt to reclaim passengers who, during the postwar decade, began using automobiles to drive to work. On September 29, 1951, the last steam-powered run was made from Yorktown Heights to the Bronx on the Putnam Division. (Courtesy of Albert Link Jr.)

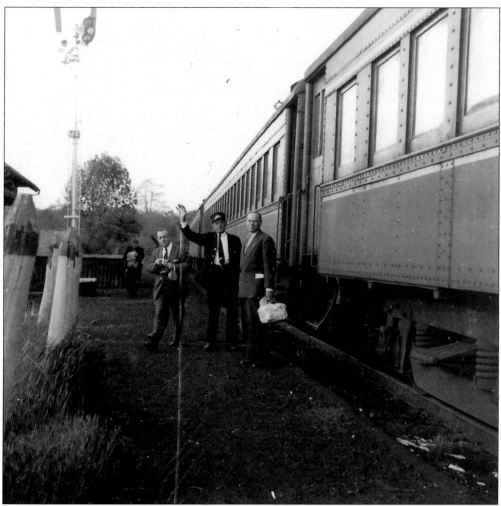

Passenger service on the Putnam Division was discontinued on May 5, 1958. This was the last commuter train out of Baldwin Place. The occasion was commemorated with certificates for the riders on that last train. Hundreds of spectators along the final route waved flags and paid their final respects to "Old Put." During the early 1960s, the Putnam Division was still a valuable line for freight trains. It ran a line between Carmel and Brewster until March 4, 1970, when the last freight train made its final run. (Courtesy of Albert Link Jr.)

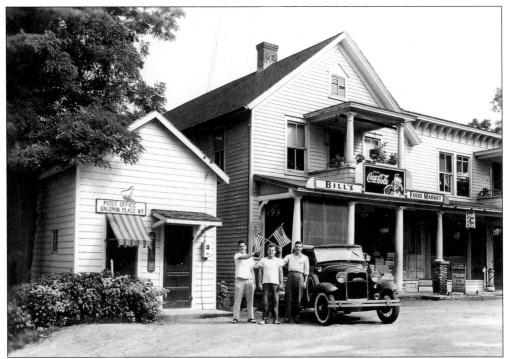

Albert Link Jr. (left) and Edward Lang (right) bid Robert Harper farewell and good luck on his induction into the army on September 13, 1942. The site is Route 118, at the Putnam-Westchester border, which runs directly through the alleyway seen in this photograph. The Baldwin Place post office was located here until it moved to the Baldwin Place Shopping Center, on Route 6, in the early 1960s. (Courtesy of Albert Link Jr.)

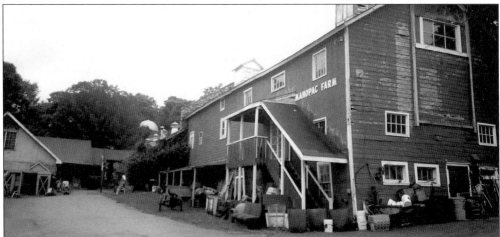

The Mahopac Farm is located on Route 6. Barney Zipkin bought 30 acres and all of the buildings in 1967 from the Borden-Willowbrook Farm Corporation, which had been operating at this site since 1915. The farm owned 110 cows and consisted of 500 acres. Borden's ceased operation in the mid-1950s and leased property to tenant farmers. Zipkin opened the country store and museum in 1968. By 1973, the Mahopac Playhouse was established. The talent included professional actors who assumed stage names. A petting zoo and pony rides with "Uncle Zip" are still part of the farm today.

Three
KENT

The town of Kent, located in the north central area of Putnam County, borders Dutchess County to the north, Philipstown and Putnam Valley to the west, Patterson to the east, and Carmel to the south. Much of the area of Kent is comprised of rough mountainous lands that are part of the Hudson Highlands, and because of this, Kent was not settled as early as the surrounding towns. Kent was originally within Frederickstown, which was named after Frederick Philipse and was organized on March 7, 1788. On March 17, 1795, Frederickstown was divided into four towns: Carmel, Southeast, Franklin (which became known as Patterson), and Fredericks. On April 15, 1817, Fredericks was renamed Kent in honor of the prominent Kent family. David Kent, son of Elihu Kent, was the most well-known in the family. He was an organizer and the first president of the Putnam County Bank, as well as of the Bank of Kent.

The settlement of Ludingtonville was located at the northeast corner of Kent. It was named after Col. Henry Ludington, an officer during the Revolutionary War, and was situated on the main road between West Point and Hartford, of great importance during the Revolution.

Cole's Mills, was a settlement on the west branch of the Croton River, about a mile south of Boyd's Reservoir. It was first settled by Elisha Cole in 1742. After the revolution, Cole's sons, David and Elisha, operated a gristmill, sawmill, and fulling mill on the property.

The area called Boyd's Corners was at the junction of old Route 301 and Peekskill Hollow Road. Named after Ebenezer Boyd, a captain during the Revolution, the tract offered the best farmland in Kent. Most of what was Boyd's Corners now lies beneath the waters of the reservoir of the same name. Land was purchased by New York City in 1866 to form the reservoir. By February 1873, the dam was complete, and by April 1, 1873, 303 acres were flooded to form the Boyd's Reservoir.

Farmer's Mills stood on the outlet stream of White Pond. The first mill was built here in 1784. By 1838, an association of farmers owned the property that by then consisted of a gristmill, a flour mill, a blacksmith shop, a tanning yard, and various other buildings. This area was known as Milltown until given the name of Farmer's Mills. The Putnam County Bank originated here on November 22, 1848. Before the railroads were built, Farmer's Mills was a very active business center.

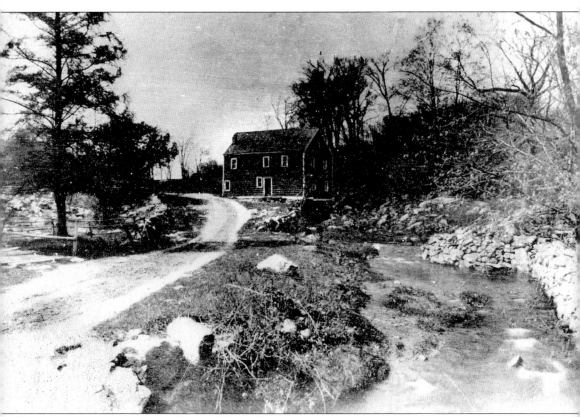

Ludington Mill used power produced by the Horse Pound Brook. In this 1938 photograph, Ludingtonville Road is seen as a dirt road. To the right of the mill is where Interstate 84 is today. (Courtesy of Kent Historical Society.)

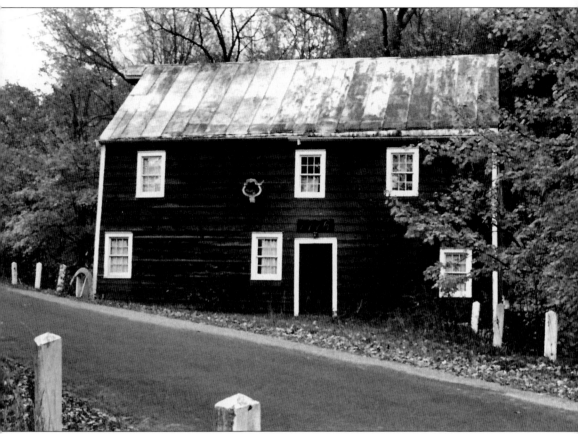

Ludington Mill is seen here in 1963. The mill was owned by Col. Henry Ludington, father of Sybil Ludington. The mill, built in 1776, was 24 feet by 36 feet and two-and-a-half stories high. The mill burned down in 1972, before it could be added to the National Register of Historic Places. (Courtesy of Frank B. Light.)

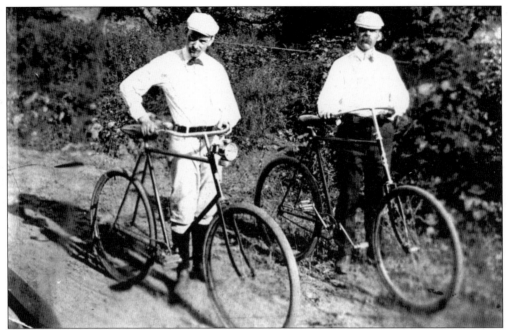

Two men pose with their bicycles on rural Farmer's Mills Road in the town of Kent in 1897. They are using a mode of transportation that was popular at the time. Judging from their appearance and dress, one would guess that they were most likely on a leisurely ride. (Courtesy of Putnam County Historian's Office.)

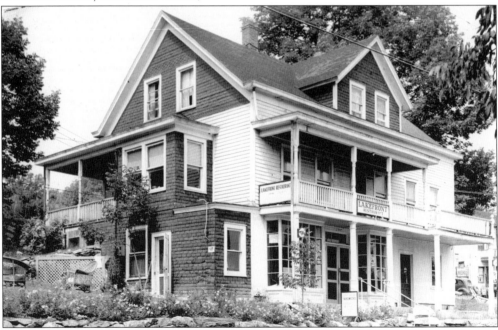

The Lakefront Restaurant is seen here in 1943. It was the original Townsend's general store, which dated back to the mid-1800s. The building is now owned by members of the Lasser family, proprietors of the antiques store on the first floor from the mid-1970s to the mid-1980s. (Courtesy of Willie Crew.)

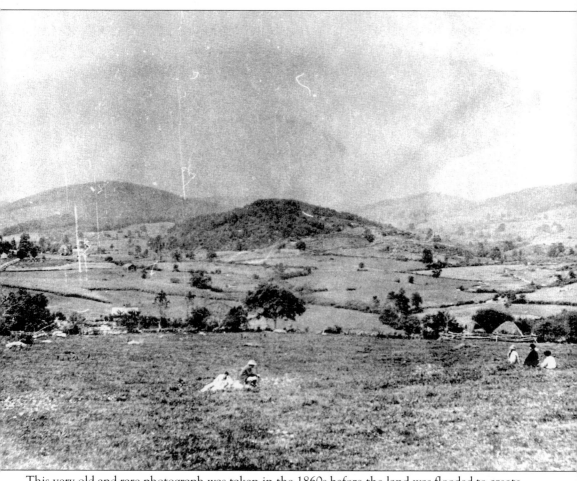

This very old and rare photograph was taken in the 1860s before the land was flooded to create Boyd's Reservoir. The view looks north at prime farmland that is now under the waters of Boyd's Reservoir. (Courtesy of Putnam County Historian's Office.)

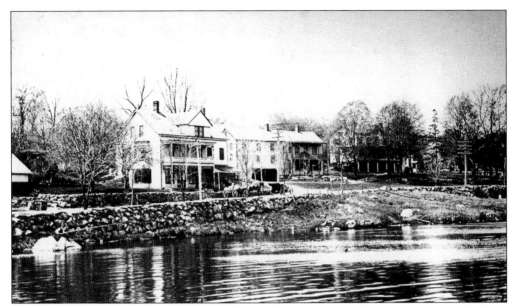

This image shows the Townsend's general store *c.* 1910. This area was called Boyd's Corners. Located at the intersection of Old Route 301 and Peekskill Hollow Road, it is now part of Kent Cliffs. (Courtesy of Kent Historical Society.)

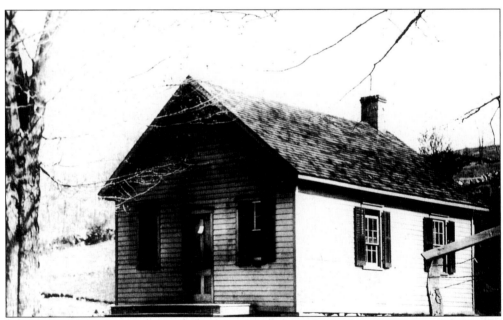

Built in 1900, this one-room schoolhouse on Farmer's Mills Road was in use until the 1950s. Classes were held in the school until 1947, and from 1947 to the mid-1950s, students were picked up here and bused to the main school buildings. This structure was then owned by the Kent Civic Association until it was purchased by the Kent Historical Society in 1976. (Courtesy of Kent Historical Society.)

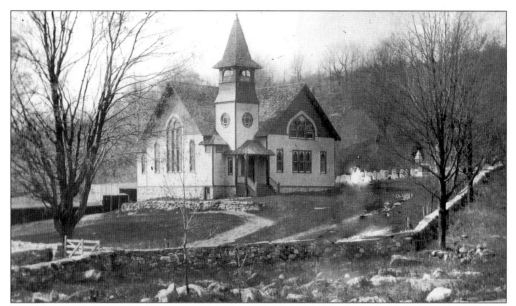

The Kent and East Fishkill Baptist Church at Farmer's Mills congregation originated in 1782. The first church was built in 1792. Due to New York City Watershed restrictions, the structure seen here was built on a site across the road in 1907. The cemetery pictured in this image dates back to the 1790s. (Courtesy of Kent Historical Society.)

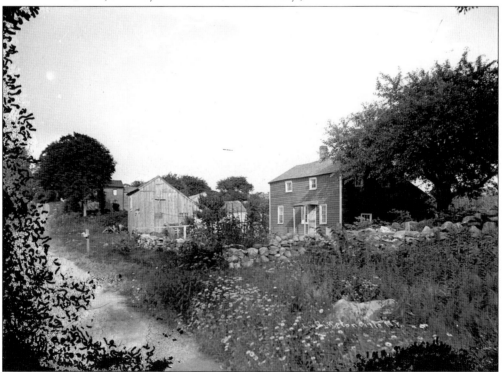

The Thomas Mead saltbox-style home was built in 1804. Thomas Mead was a very wealthy farmer in the Farmer's Mills area. This image is from a c. 1890 glass plate negative. The house is still standing today. (Courtesy of Kent Historical Society.)

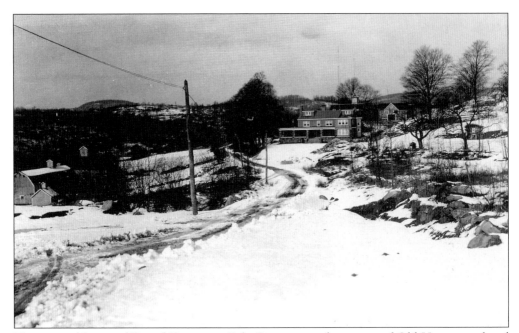

The original home of Daniel Kent is at Yale Corners, on the corner of Old Horsepound and Farmer's Mills Roads. Yale Corners was named after Benjamin Yale, a state legislator in the early 1800s. The Slaughter W. Huff Pony Farm operated here in the 1940s. The building is now Cutillio's Restaurant. (Courtesy of Frank B. Light.)

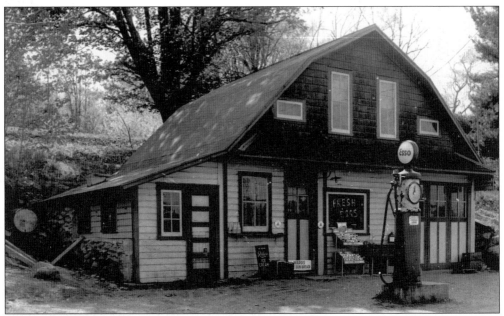

Albert and Helen Walsh acquired this building in the 1930s, and it was called Helen's Store. Ruth Klein, daughter of the Walshes, inherited the store in the 1960s, and it is now owned by her son Edward Klein. Today, the business is known as the Kent Cliff store on Route 301. The gas pumps still stand as a reminder of when gasoline was priced at 18¢ a gallon. (Courtesy of Willie Crew.)

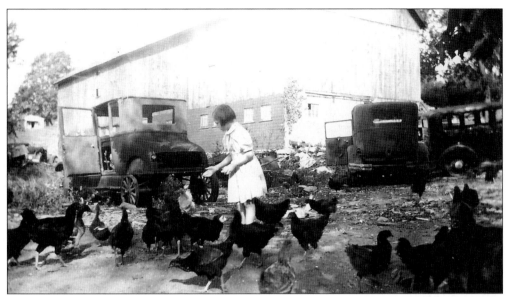

Rosetta Forshay was a schoolteacher at Farmer's Mills School and others in Kent. She is seen here as a child feeding chickens at the Forshay farm, on Ninham Road, in the late 1920s. Forshay Corners were named after her family. Members of her family held prominent positions in the area such as school commissioner of Putnam County, town supervisor, and county coroner. (Courtesy of Frank B. Light.)

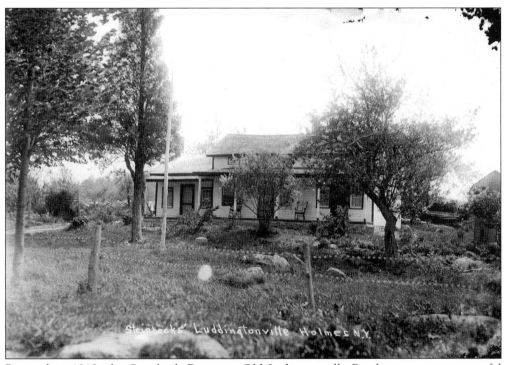

Pictured in 1910, the Steinbeck Farm, on Old Ludingtonville Road, was a very successful enterprise in the late 1800s and early 1900s. The farmhouse still stands today as a private residence. (Courtesy of Kent Historical Society.)

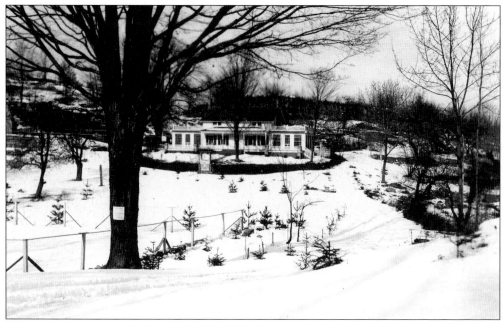

The Robert J. Lee homestead, on Farmer's Mills Road in the south lake section of Kent, is seen in this 1931 photograph. Robert Lee was a successful farmer and justice of the peace in the early 1800s. This was a patent house dating back to *c*. 1790. (Courtesy of Frank B. Light.)

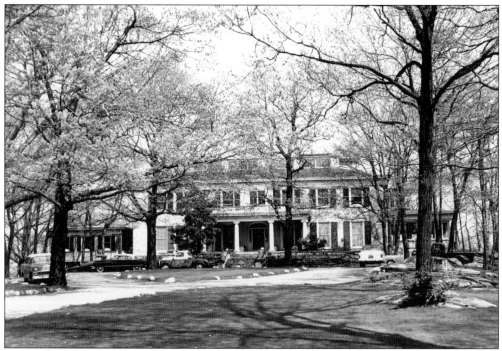

The Carmel Country Club was taken over by the Sedgewood Club in the 1950s. This building was damaged by fire in the mid-1980s and then was rebuilt. The club is located off Route 301, overlooking the West Branch Reservoir. (Courtesy of Willie Crew.)

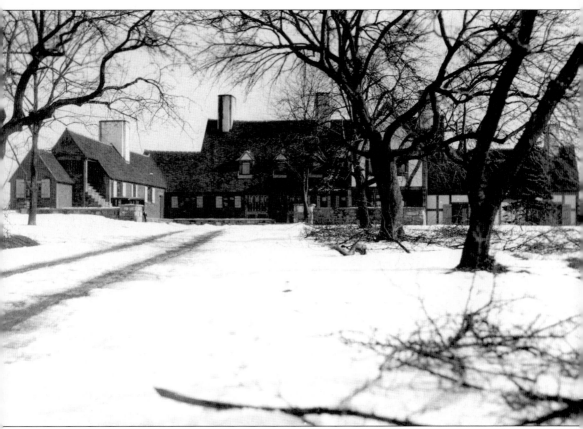

Dreamwold was considered by many as the finest restaurant in Putnam County. The business dates back to the 1890s, and it finally closed in the mid-1980s after a series of fires. A circular drive led to beautifully landscaped gardens and patios with scenic views of the surrounding area. The restaurant, pictured in 1931, catered to the most elegant and refined diners. (Courtesy of Willitt C. Jewell.)

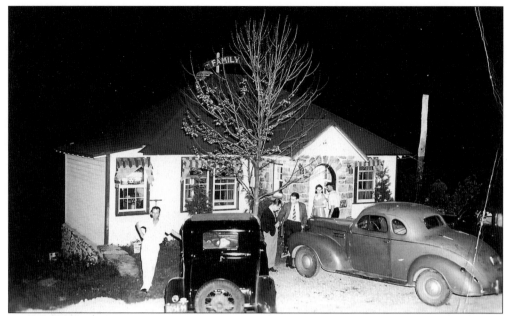

The Family Inn was owned by Tony Randazzo and was situated on the Kent-Carmel border on Route 52. The inn featured good food and even better music. A 1930 Model A Ford is parked on the left, and a 1937 Plymouth coupe on the right. The building is long gone. (Courtesy of Albert Link Jr.)

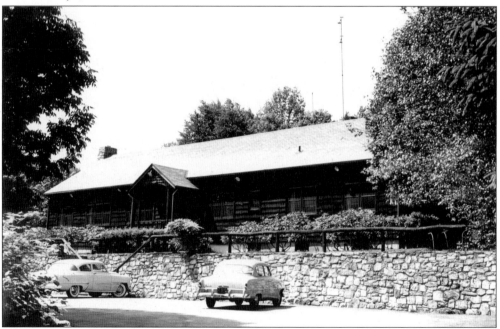

Bolla's Restaurant, shown in 1954, was formerly the Winter Garden Farms Restaurant. The original owner was Chic Johnson, a famous vaudeville entertainer from the team of Olsen and Johnson. The restaurant was named after the theater they worked in. After changing hands several times, the building burned in the mid-1980s. Today, it is the home of the new Lake Carmel Fire Department. (Courtesy of Willie Crew.)

The Winter Garden Farm, on Route 52, was a very successful dairy farm from the 1940s to 1951. It was owned by Chic Johnson, who hosted returning and injured GI's for rest and relaxation. Starlets visited and entertained the soldiers. Johnson and his daughter June Mayes were very involved with the USO (United Service Organizations). (Courtesy of Richard Muscarella.)

Dr. Elias Cornelius donated the land on Gipsy Trail Road for the Putnam County Poor Farm in 1820. The poor farm was a tax-supported residential institution where people were required to go if they could not support themselves. Poorhouses were started as a less expensive alternative to what was then called outdoor relief. The Putnam County Poor Farm closed in the 1970s, and the house burned a short while later. Only a barn remains today on the property, which is now the Putnam County Memorial Park.

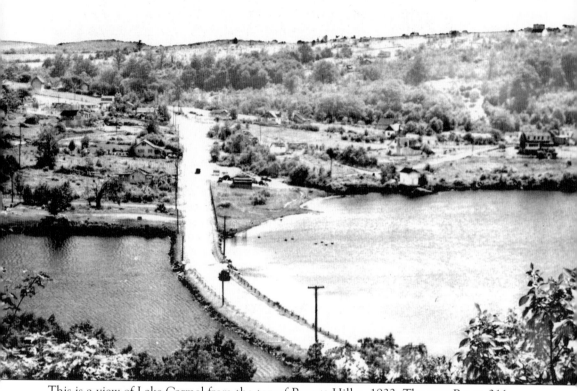

This is a view of Lake Carmel from the top of Barrett Hill *c.* 1932. The new Route 311 passes over the causeway toward Patterson. The old road lies under the man-made lake on the right. The main beach of Lake Carmel is in the cove next to the causeway. (Courtesy of Putnam County Historian's Office.)

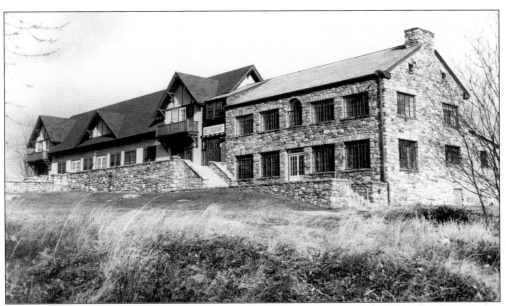

The Lake Carmel Clubhouse was built *c.* 1933. It served as a meetinghouse and recreation building of Lake Carmel property owners. During the summers, rooms were rented to guests on a short-term basis. The building housed several restaurants until the 1960s. Today, the building is privately owned and consists of several rental apartments. (Courtesy of Willie Crew.)

Lake Carmel was owned and developed by the Smadbeck brothers in the early 1930s. The land was divided into lots and sold through the *Daily Mirror* newspaper. A minimum of four lots was required to build a cottage. The first groups of homeowners were mostly Irish and German police officers and firefighters from New York City. The lake communities were geared for middle-class families. After the Depression years and especially after World War II, times were prosperous and families were able to live comfortably on one salary. (Courtesy of Denis Castelli, the Taconic Postcard Club.)

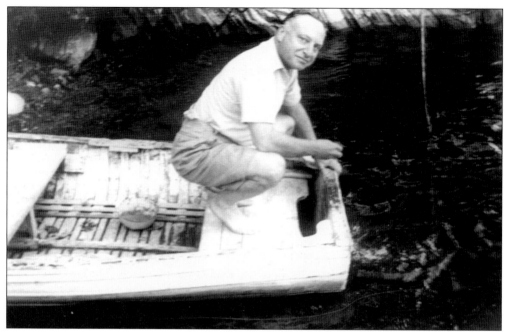

Arthur Smadbeck, seen here in the 1950s, and his brother Warren Smadbeck laid out the plan for Lake Carmel, along with engineer Roy A. Burges. The Smadbecks were involved in town projects and lived on Lake Carmel. (Courtesy of Putnam County Historian's Office.)

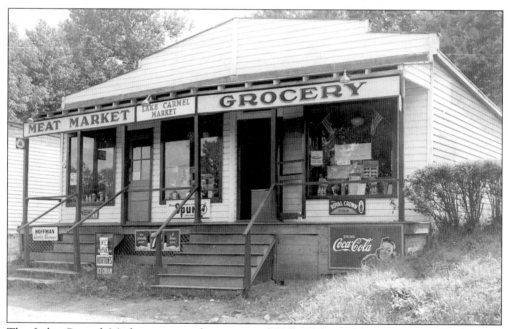

The Lake Carmel Market was on the corner of Hillandale and Towners Roads. This was considered the unofficial center of Lake Carmel. When this picture was taken in 1947, bread cost 10¢ a loaf, milk cost 25¢ a gallon, and there was plenty of loose penny candy. Most of the brands of soda advertised on the signs no longer exist. A delicatessen is in business in this building today. (Courtesy of Kent Historical Society.)

Four

SOUTHEAST

Formed in 1795, Southeast was originally part of Frederickstown. True to its name, the town is located in the southeast section of Putnam County. The first settlers came to this area from Long Island and Westchester *c.* 1730. The east branch of the Croton River provided energy for various mills here. The land around the river proved to be fertile and conducive to farming. Eventually, small settlements formed along the banks of the Croton River. Milltown dates back to 1745, when Morehouse's Mill operated here. There were also a school and a tavern on the road to Danbury, Connecticut. The land around Dykemans Station belonged to the Dykeman family and was located on the Harlem Railroad line. Southeast Center, earlier called Sodom, was an area along the Croton River that included several farms; the largest of these belonged to Moody Howes. Much of this farmland was flooded to form the Middle Branch Reservoir.

The mountainous regions of Putnam County contained various metals. The iron ore found in this area gave rise to the many iron mines of Putnam County. None was of greater importance and greater value than the Tilly Foster Mine. Originating in 1864, the Tilly Foster Mine Company harvested 300 tons of iron ore per day until 1895, when the supply dwindled and the mind was closed.

The village of Brewster is within the town of Southeast. In February 1848, James and Walter Brewster acquired the land that comprises this village from Gilbert Bailey for the price of $8,000. At the time, an iron mine was located on the site and the Harlem Railroad eventually passed through the property on its way to Pawling. A stream on the western border provided waterpower. By 1849, the railroad was finished, a depot was built, and Main Street was opened. Brewster became known as "the hub of the Harlem Valley" because of the railroad junction. It was the most populated village during the 1800s and into the 1900s. Stagecoaches came from Danbury to meet the train, and eventually, houses and businesses were built here. The area was originally referred to as Brewster Station.

The Borden Condensed Milk Company in the village of Brewster was established in 1864. The factory was the largest and most efficient of its kind, with 30,000 quarts of milk condensed per day and shipped worldwide via the railroad. It was located on the shores of the east banks of the Croton River at Routes 6 and 22.

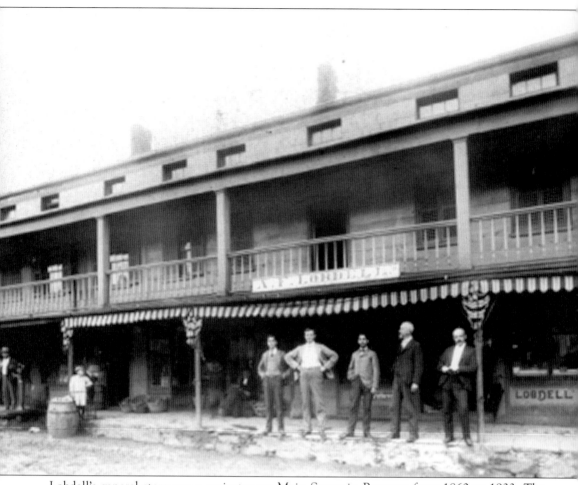

Lobdell's general store was a mainstay on Main Street in Brewster from 1860 to 1933. The original proprietor was Alexander F. Lobdell. The first Brewster post office was established in this store. In 1863, Lobdell was appointed first postmaster of Brewster by Pres. Abraham Lincoln, and he served in that capacity until 1887. His business continued to grow, and eventually, his son Alexander Jr. served their loyal customers. In 1933, the son retired from Lobdell's and became employed by the Putnam County Savings Bank. (Courtesy of Southeast Museum, Brewster, New York.)

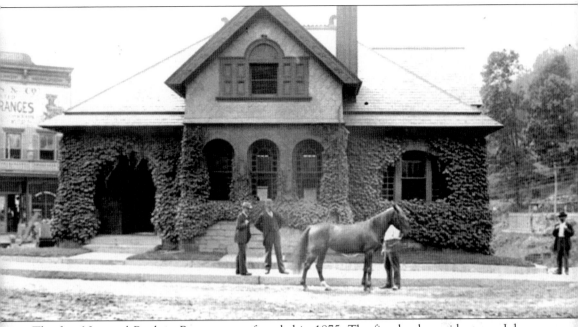

The first National Bank in Brewster was founded in 1875. The first bank president was John Gail Borden, the son of Gail Borden, who invented condensed milk. Frank Wells, a former bookkeeper at the Borden's factory, was the head cashier. The bank did business in various locations in the village until the building seen here was constructed in the winter of 1885–1886. (Courtesy of Southeast Museum.)

Stonehenge was the first estate owned by Seth B. Howse, who greatly enlarged the building and beautified the grounds around it. The property was situated near Sodom Reservoir, and Howse's wife lived in fear that the 400-foot-long, 70-foot-high masonry reservoir dam would collapse and cause certain catastrophe. For this reason, in 1892, Howse built an even greater estate on Turkhill Road, called Morningthorpe. (Courtesy of Southeast Museum.)

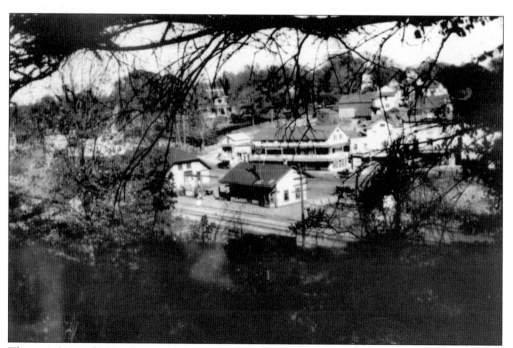

This is a view of Main Street from Marvin Mountain prior to 1931. Sometimes referred to as Marvin Hill, it is the highest point one sees when entering the village of Brewster. The building in the center is the train station, and to the left of it is the freight railroad station. The large building beyond the station is Lobdell's general store. (Courtesy of Southeast Museum.)

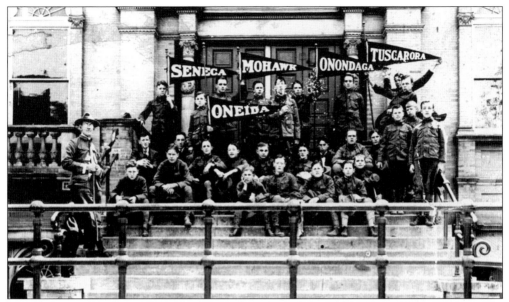

The Brewster Boy Scout Troop poses on the steps of the old town building in 1912. The building is the home of the Southeast Museum today. Chicago publisher William D. Boyce filed incorporation papers for the of the Boy Scouts of America in Washington, D.C., on February 8, 1910, modeling his Scouts after their British counterparts. (Courtesy of Southeast Museum.)

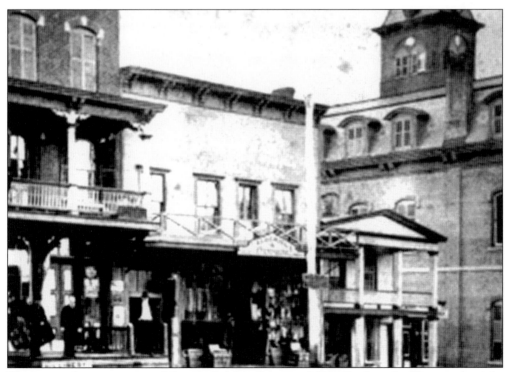

This image shows a portion of Brewster's Main Street in 1890. The large building on the right is the Southeast Town Hall, which replaced the town hall that burned in 1882. (Courtesy of Southeast Museum.)

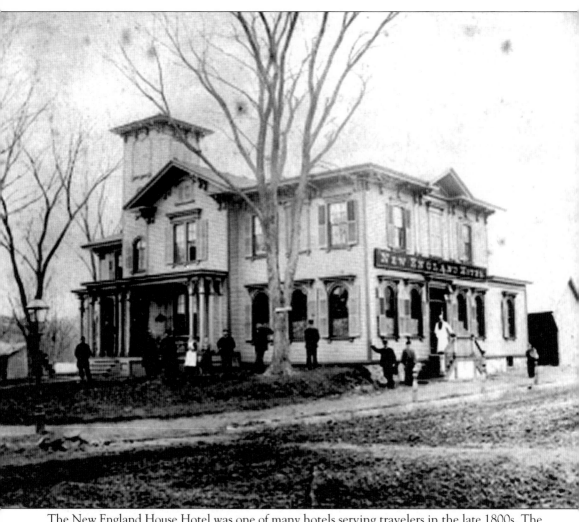

The New England House Hotel was one of many hotels serving travelers in the late 1800s. The hotel was located on North Main Street in Brewster. (Courtesy of Southeast Museum.)

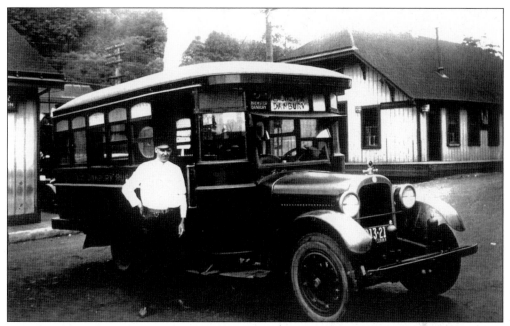

T. J. Fenaughty drove this bus from Brewster to Danbury, Connecticut, in the 1920s. He is seen here waiting for passengers at the Brewster train station. (Courtesy of Southeast Museum.)

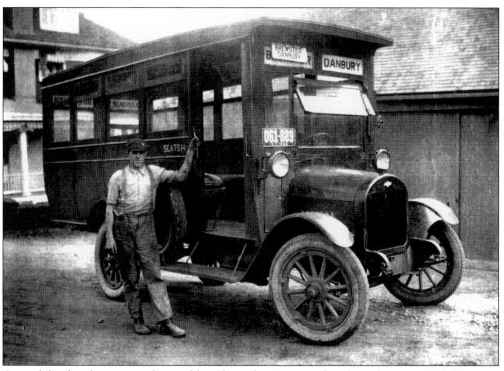

One of the first buses manufactured by Chevrolet is pictured with its driver on Oak Street in the village of Brewster c. 1915. The vehicle had a seating capacity of 14. This bus replaced the horse-drawn wagon of the pre-automobile age. (Courtesy of Southeast Museum.)

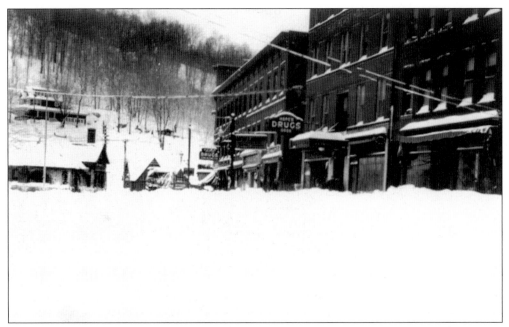

Main Street is deserted after this snowstorm in 1934. The Brewster train station can be seen on the left. (Courtesy of Southeast Museum.)

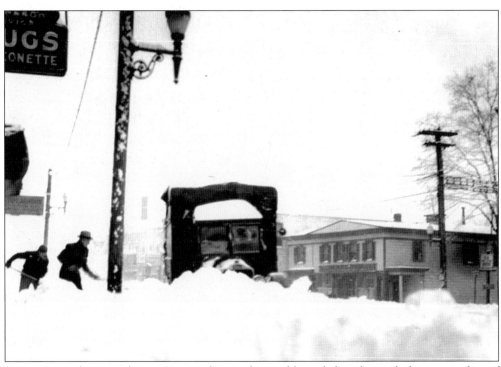

Brewster merchants and store owners dig out from a blizzard that dumped almost two feet of snow on Main Street in 1934. (Courtesy of Southeast Museum.)

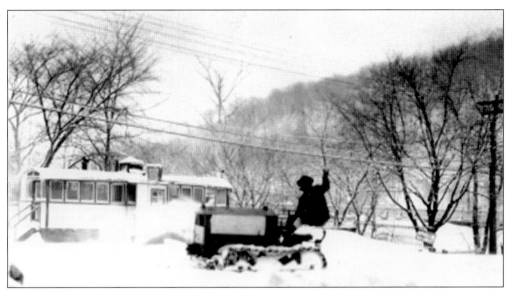

The original Bob's Diner is seen here in 1934. This building was razed in the 1950s, and the current diner was built in the same general location. The diner continues to be a popular eatery and meeting place, convenient to commuters of the train station. (Courtesy of Southeast Museum.)

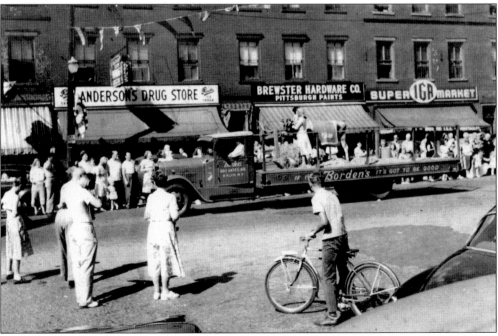

During the week of August 8–14, 1948, Brewster celebrated the centennial of its founding. Some 300 children marched in costume in a parade down Main Street. The Borden Dairy mascot, Elsie the Cow, passes by on this flatbed truck. The company slogan is "If it's Borden, it's got to be good!" Hundreds of cows posed as Elsie around the country. Centennial week ended with the Calico Ball, sponsored by the women's club and the firemen. John Reed King of radio fame served as the host and master of ceremonies. (Courtesy of Southeast Museum.)

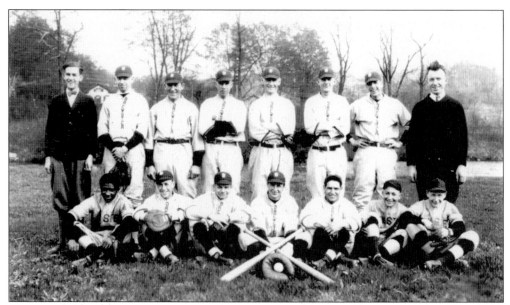

Brewster High School had a strong baseball program in 1924. The team was crowned Northern Westchester and Putnam County champions. Brewster defeated Pleasantville High School 15 to 4 at Electrazone Field. (Courtesy of Southeast Museum.)

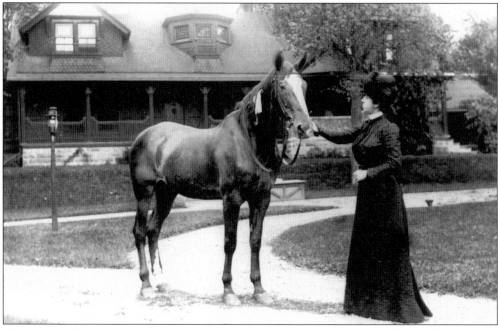

Lilly Deacon Forepaugh was a famous circus equestrienne who lived in Southeast. She is shown here in 1896 with her prizewinning horse at Stonehenge. Lilly Deacon came to the United States from England to join the Adam Forepaugh Circus. During her first season with the circus, she married Adam Forepaugh Jr., the star animal trainer for his father's business. She eventually went on to perform for the famous circus proprietor Seth B. Howes. After she retired, she lived out her life as a recluse in Brewster. She was always fond of children and animals. (Courtesy of Southeast Museum.)

Lilly Deacon Forepaugh donated this water trough to the village of Brewster in 1912. She had a great love for animals and was the founder of the Society for Kindness of Dumb Animals. She was known to give a penny to any child who had done a good deed for an animal. The trough was eventually removed and used for scrap iron during World War I. (Courtesy of Southeast Museum.)

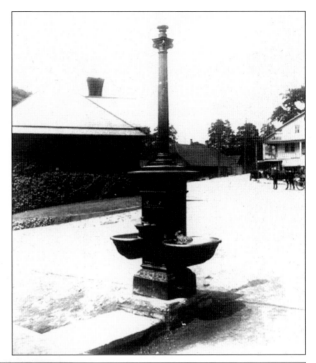

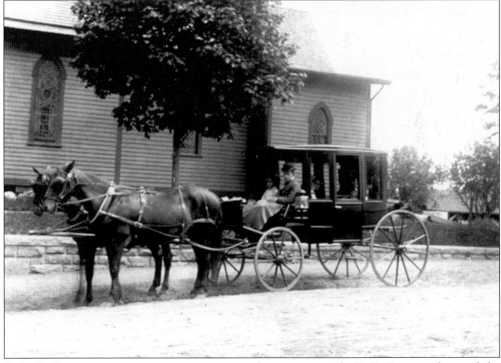

Seth B. Howes was a circus entrepreneur and a partner with P. T. Barnum for a while. He is seen outside St. Andrews Church, on Prospect Avenue. This wooden church was built in 1881. Howes funded a new church that replaced this one in 1901. His funeral Mass was the first one held at at the chapel, which still stands today. (Courtesy of Southeast Museum.)

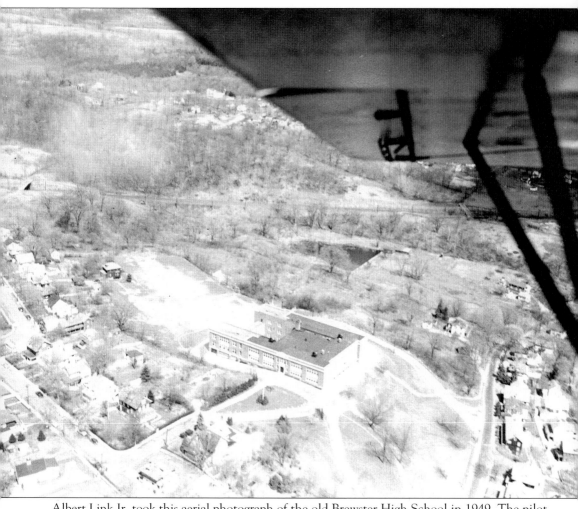

Albert Link Jr. took this aerial photograph of the old Brewster High School in 1949. The pilot of the Piper Cub airplane was Howard "Buz" Chorsky. The flight was out of Somers Airport, on Route 100, where Pepsico Company is today. Students attended this school until the new high school was built in 1980. (Courtesy of Albert Link Jr.)

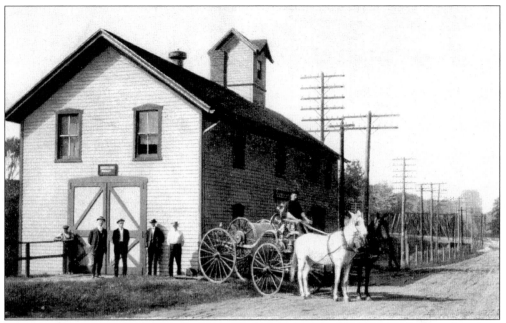

The first Brewster firehouse was built on North Main Street opposite the Baptist church in 1880. A new, more modern and spacious firehouse was built north of where Route 6 crosses the railroad tracks on Railroad Avenue in 1941. (Courtesy of Southeast Museum.)

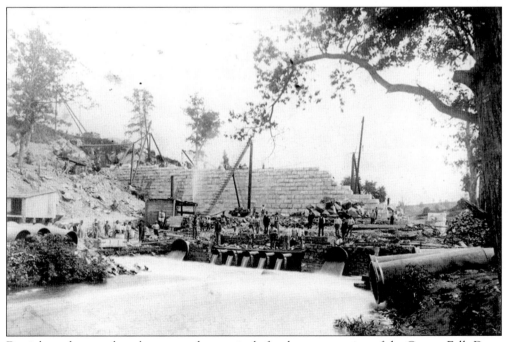

Derricks and steam shovels were used extensively for the construction of the Croton Falls Dam. Many Italian stonemasons were employed to build these dams in the 1800s. The ancestors of these masons contribute to the large Italian-American population in Putnam County today. (Courtesy of Southeast Museum.)

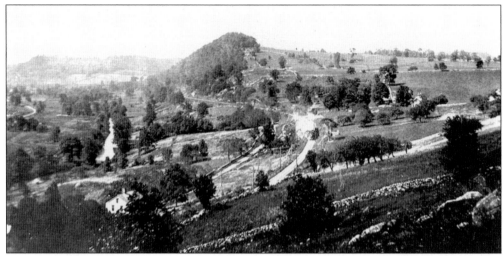

All of the land to the left of the Harlem railroad tracks seen here was flooded to create the Diverting Reservoir. The houses in this photograph are gone, having been moved to another location or demolished. This impoundment was constructed in 1906. It had a surface area of 127 acres and a maximum depth of 39 feet. (Courtesy of Southeast Museum.)

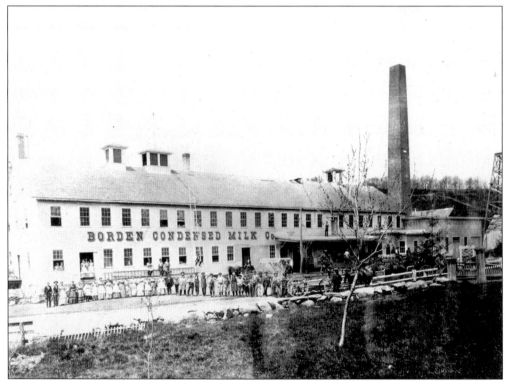

The Borden Condensed Milk Company was founded in 1863 and incorporated on January 28, 1864. Gail Borden invented the plan for condensing milk and was awarded a patent in 1853. The Civil War brought a great demand for his product, and he quickly became a millionaire. The Borden family helped build schools, the town hall, and the Baptist church in Brewster. (Courtesy of Southeast Museum.)

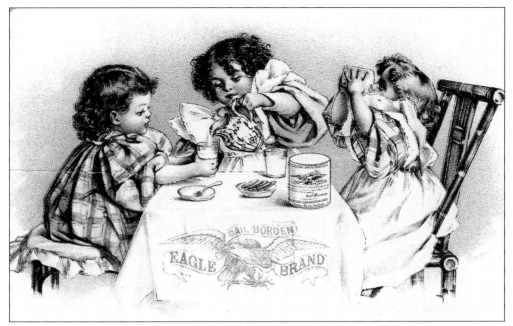

Advertising cards for Borden's condensed milk had recipes on the back. They were used as a type of business card. This card told how good Borden's milk was for infants and newborns. (Courtesy of Southeast Museum.)

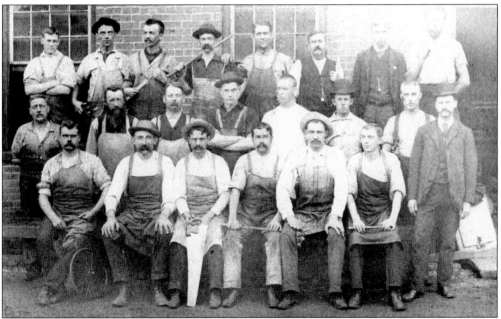

Borden Condensed Milk Company factory workers are seen with their tools in 1893. Borden's was a major employer for Brewster and the surrounding areas. The company paid fair wages and supplied steady employment. Many wives of the male employees worked the night shift after their husbands returned home. Most of the women worked in the canning department, sealing cans. After their shift the women were given a ride home by the company. (Courtesy of Southeast Museum.)

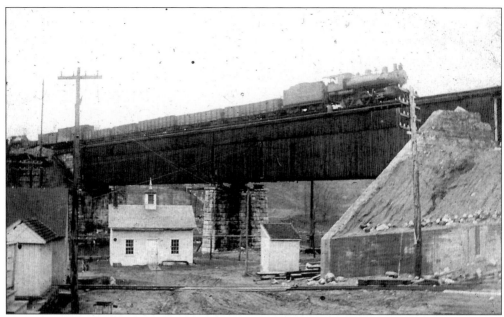

A branch of the New Haven Division Railroad linked Brewster to Danbury, Connecticut, and New England. This 1890s scene shows a train heading toward Brewster by way of the Borden's Bridge. The East Branch of the Croton River flows under the span, which is used as an auxiliary track today. (Courtesy of Southeast Museum.)

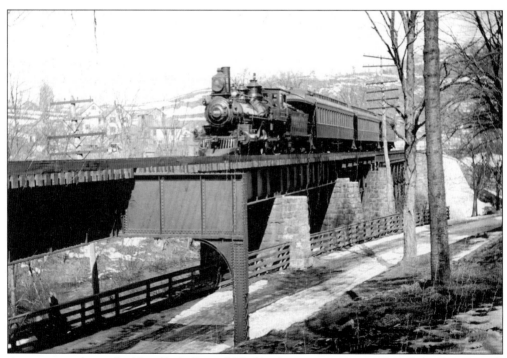

A steam engine on the New York Central Harlem line crosses Route 22 and the East Branch of the Croton River just south of Brewster. A kerosene fuel headlamp was used in the period of the 1890s. The bridge is still in use today. (Courtesy of Southeast Museum.)

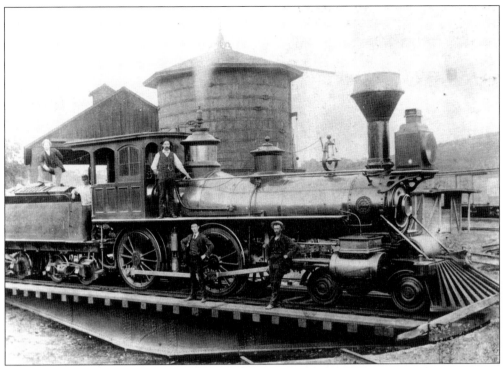

This Brooks model steam engine served the New York City and Northern Railroad (Putnam Division) in 1880. There was a fleet of seven. The crew of No. 5 is seen here on a turntable in Brewster c. 1885. (Courtesy of Putnam County Historian's Office.)

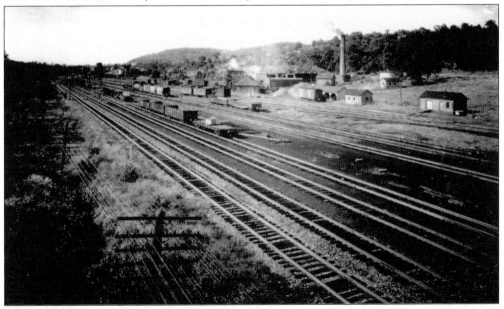

The Putnam Junction of the New York Central Yard on the Harlem and Putnam Divisions is viewed here from Prospect Hill c. 1950. To the left of the chimney is the roundhouse, and the coaling station is seen in the distance. Brewster became home to many rail men. (Courtesy of Carmel Historical Society.)

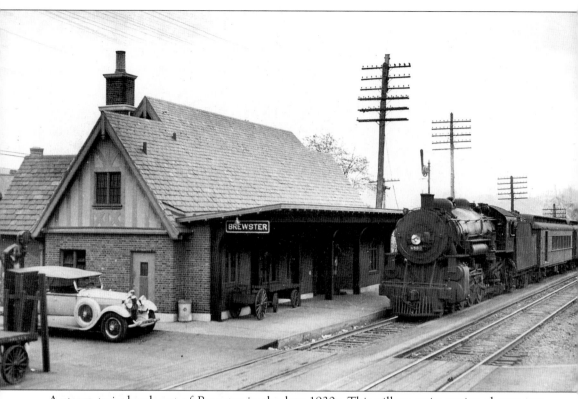

A steam train heads out of Brewster in the late 1930s. This village train station shown was completed in 1931. The first station was built in 1849 by Walter Brewster.

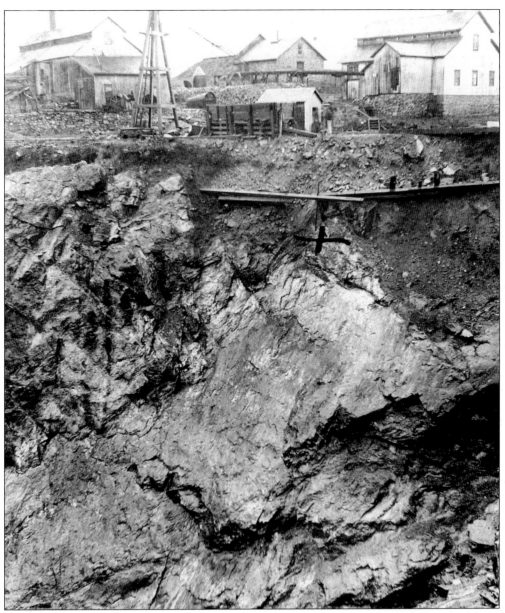

An avalanche caused the death of 13 workers at the Tilly Foster Mine in 1895. At the height of production, 300 workers were employed here. The open pit mine was a huge crater 600 feet deep. As water filled the crater, tunnels were dug into the sidewalls to harvest iron ore. This procedure was considered dangerous, and the mine eventually closed in 1897 when a new mine was opened in Mesabi, Minnesota. (Courtesy of Southeast Museum.)

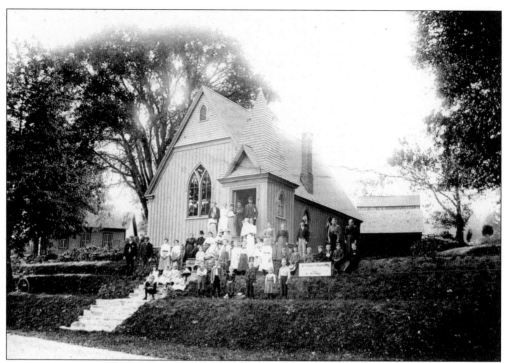

The congregation of St. Paul's Episcopal Chapel is seen here *c*. 1900. The church and school (left) served workers of the Tilly Foster Mine. Both remained after the mine closed, until the 1930s. (Courtesy of Southeast Museum.)

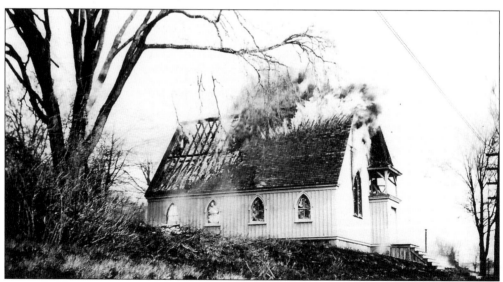

Fire consumes St. Paul's Episcopal Chapel at 10:30 a.m. on April 30, 1930. The church was located on the corner of old Route 6 and Simpson Road. A Native American gift shop occupies this site today. (Courtesy of Frank B. Light.)

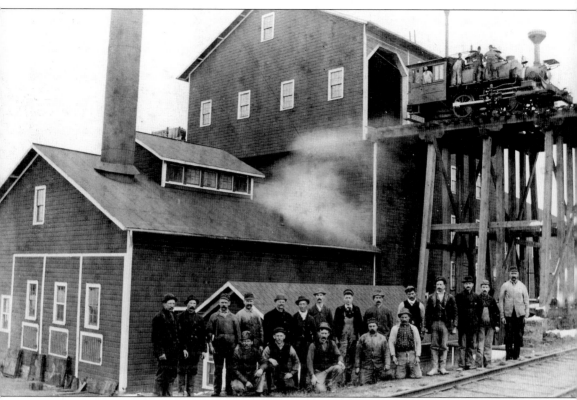

The New York and Boston Railroad ran a branch from the Tilly Foster Mine to the village of Brewster. Iron ore was sent from Brewster to New York City and then to Pennsylvania to be melted and used for steel. Irish, Italian, Swedish, and Hungarian immigrants worked at the mine, and many of their descendants live in the area today. (Courtesy of Southeast Museum.)

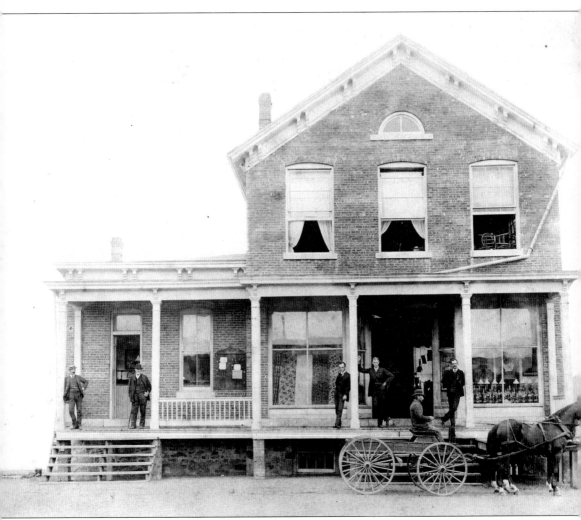

The Tilly Foster Mammoth Store sold dry goods, groceries, and equipment to the minors c. the 1880s. The workers lived in a community near the mine that became known as Tilly Foster. The area had its own post office and train station. The railroad continued to serve the area, which was two miles west of Brewster, after the mine closed in 1897. (Courtesy of Southeast Museum.)

Five

PUTNAM VALLEY

The area that is today the town of Putnam Valley was a part of Philipstown until it separated on March 14, 1839. The town was called Quincy until February 13, 1840, when the name was changed to Putnam Valley. The town is made up of two valleys called Peekskill and Canopus Hollows. These valleys run the entire length of the town. Peekskill Hollow originates at the headwaters of Peekskill Creek, which is located in Kent's Cliffs near Boyd's Reservoir. The creek flows the entire length of Putnam Valley and eventually empties into the Hudson River, where its mouth is the Annsville Creek. The hollow was created when a glacier moved through ages ago. Canopus Hollow is surrounded on both sides by rugged hills and mountains. This hollow runs from northeast to southwest, and its creek empties into the Annsville Creek and also flows into the Hudson River.

The first settlers came to this area c. 1740. Thomas Bryant, who gave his name to Bryant Hill and Bryant Pond, was one of the first inhabitants. The Barger family arrived from Germany in 1780. Peter Barger bought 213 acres of land from the commissioners of forfeiture. Barger Pond takes its name from his family.

At the south end of Putnam Valley is Adam's Corners. The Dusenburys were the first inhabitants of this area and owned a farm of 300 acres. By the early 1800s, this settlement consisted of a general store, a post office, a schoolhouse, and later, a telephone exchange. Tompkins Corners is situated at the intersection of Wiccopee and Peekskill Hollow Roads. A. J. Tompkins built the first store here. A sawmill, cider mill, post office, and schoolhouse also stood here. The Tompkins Corners Methodist Church was built here in 1835. The church burned and was rebuilt in 1891. Gasoline was sold here for the earliest automobiles.

In the northwest corner of town is Oregon Corners. Oregon consisted of a church, blacksmith shop, paper mill, general store, and post office. By the late 1800s, the area became quite an important village of Putnam Valley. The trolley ran from the Peekskill train station to Oregon Corners. Passengers from New York City then boarded a stagecoach to be taken to points as far north as Lake Oscawana. The area continued to flourish, and by 1905, the Oregon School was established. In the central region of Putnam Valley is a lake now called Oscawana Lake. The original name was Horton's Pond, named after John Horton, who purchased most of the land surrounding this lake in the late 1700s. The lake has an area of 601 acres and an average depth of 30 feet. The picturesque beauty of this lake gave rise to the many boardinghouses, inns, and camps built here. During the late 1800s and through the mid-1900s, Oscawana Lake was a popular resort for middle-class citizens.

The mountainous regions of Putnam Valley yielded a great quantity of excellent iron ore. High-quality iron ore was harvested at Sunken Mine and sent via narrow-gage railroad to the Philipstown Turnpike (today, known as Route 301). In 1828, the West Point Foundry Association acquired a tract of land that produced huge amounts of iron ore. Thousands of tons of iron ore were taken from the Denny Hill Mine in the mid-1800s. These mines were located in the area known today as Clarence Fahnestock State Park.

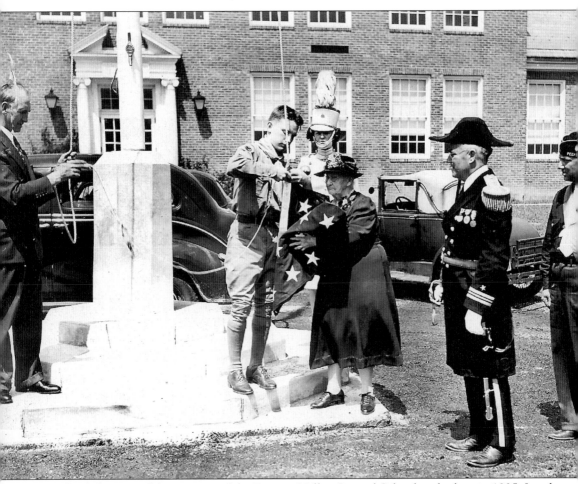

The dedication of the opening of the Putnam Valley Central School took place in 1935. Israel Ben Shieber was president of the school board at the time and was instrumental in the building of this school. Retired naval officer Elijah Tompkins (second from the right) stands in full uniform at the flag-raising ceremony. (Courtesy of Putnam Valley Historical Society.)

Abraham Smith, an early settler from Suffolk County, Long Island, built this house on the corner of Bryant Pond Road and Wood Street in the mid-1700s. His grandson Saxton Smith lived here and went on to be a man of great importance. Saxton Smith was elected to the state assembly in 1839, 1843, and 1862. He was elected supervisor of Putnam Valley in 1840. His distinguished reputation led to his being elected state senator in 1845, 1847, and for a third term in 1863. The Smith property was purchased by Ruban Gilbert in the late 1800s and was then known as the Interlake Farm. (Courtesy of Sallie Sypher.)

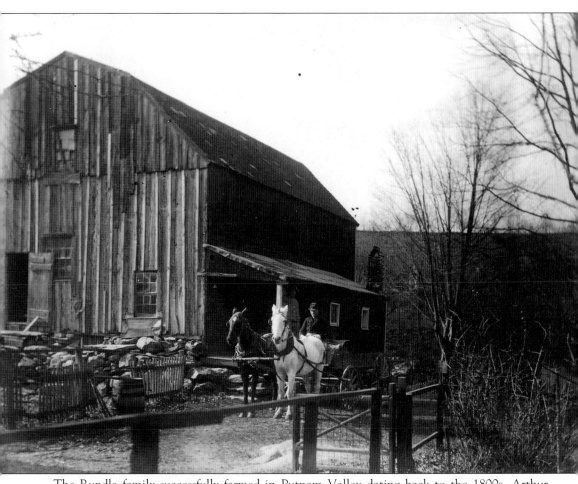

The Rundle family successfully farmed in Putnam Valley dating back to the 1800s. Arthur A. Rundle is seen here at the Rundle Mill with his team of horses c. 1895. (Courtesy of Putnam Valley Historical Society.)

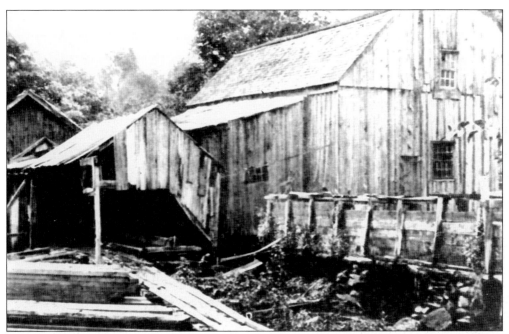

The Rundle Mill was located on Mill Street. It operated as a gristmill from 1788 to 1938. A sawmill and cider mill were also on this site. An original millstone is on display today in a miniature mill on the property.

The Lewis Brothers Toothpick Factory was started in the late 1800s and was operated by the Lewis brothers until the 1920s. Silver birch trees were used to make the toothpicks. The factory was located on Peekskill Hollow Road, just west of today's Putnam Valley High School. (Courtesy of Putnam Valley Historical Society.)

Until the Putnam Valley post office was established, all mail came from Peekskill. Mail was delivered to local post offices in town via horse and buggy by Vincent Crawford, seen here in 1910. Crawford lived at Oregon Corners and delivered mail to the Adams Corners, Oscawana, and Tompkins Corners post offices. (Courtesy of Putnam Valley Historical Society.)

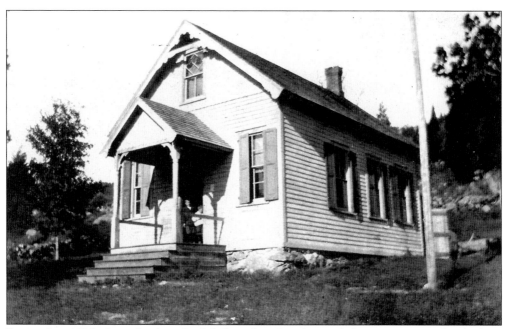

Pictured in 1925, this school on Peekskill Hollow Road served the community of Tompkins Corners. Most schools were no more than two or three miles apart. Students walked to school or were given rides in horse-drawn wagons. (Courtesy of Putnam Valley Historical Society.)

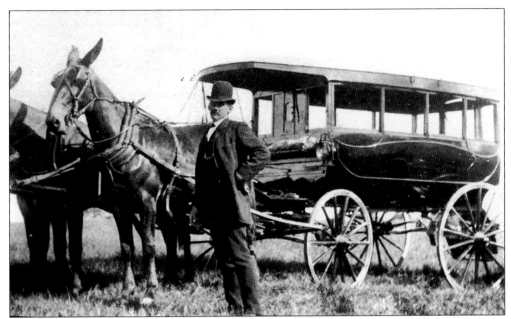

Absolem Sherwood ran a stagecoach from Peekskill to Lake Oscawana. Sherwood is seen here on Oregon Road *c*. 1900. He took travelers from the Peekskill train station to the summer resort hotels. During the winter he delivered coal to the mills in the valley. He bought one of the first automobiles and used it as a taxi, driving it with abandon, just as he drove his stagecoach. (Courtesy of Putnam Valley Historical Society.)

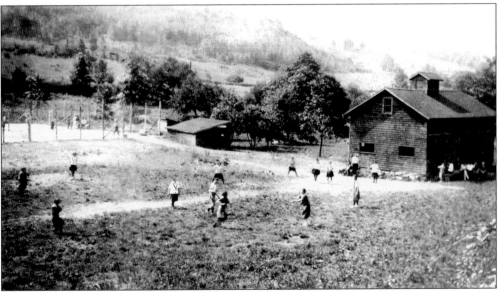

Inner-city children came to Camp Rossback, on Peekskill Hollow Road, near Tompkins Corners, to spend their summers. In the late 1920s, under the guidance of Israel Ben Shieber, the camp became known as Camp Madison Felicia. The *Herald Tribune* Fresh Air Fund originated in 1877 as a sponsor of the camp. Today, Camp Combe is located on the site and run by the YMCA. Some buildings have been restored to their original state. (Courtesy of Putnam County Historian's Office.)

The Tompkins Corners United Methodist Church was built in 1891. Meetings were held by the Methodist society, dating back to 1789. Land was acquired from Bartholomew Tompkins in 1835, and the original church was built soon after. The first trustees were Ananias Tompkins, David Reed, and Morris Baxter. The carriage shed was built between 1880 and 1882. The property was listed as a historical site in 1883.

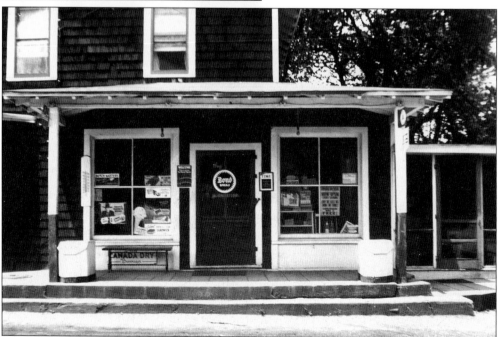

Adams Corners was a busy settlement at the junction of Church Road, Peekskill Hollow Road, and Mill Street, dating back to Revolutionary times. It had a school, Grange, post office, and cemetery. The general store, pictured here, existed as far back as the 1860s. The town's first telephone exchange was housed inside. (Courtesy of Putnam Valley Historical Society.)

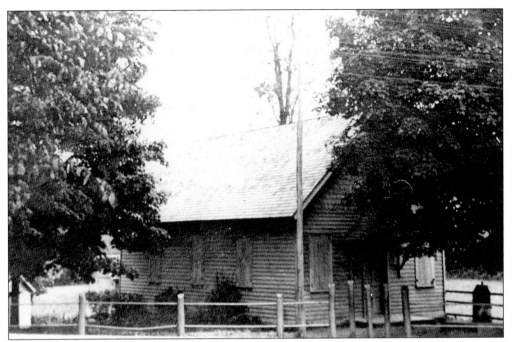

This photograph of the Adams Corner Schoolhouse was taken in 1915. Built c. 1846, the school was one of the original five that were combined in 1935 to form the Putnam Valley School District. Today, this building serves as the Putnam Valley Historical Society Museum. (Courtesy of Putnam Valley Historical Society.)

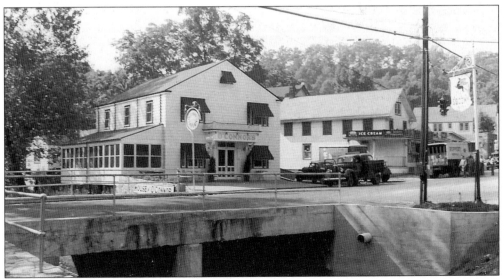

A view of Oregon Corners in the 1940s shows O'Connor's Tavern and the IGA store, which was the forerunner of today's supermarket. The Oregon Bridge is seen in front of the tavern. (Courtesy of Putnam Valley Historical Society.)

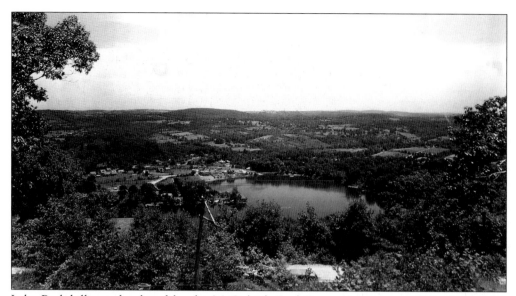

Lake Peekskill was developed by the McGolrick Real Estate Company c. 1921. Prospective buyers were brought from New York City by bus to view the property around the man-made lake and resort. The starting price of a 100- by 110-foot lot was $475. A plot could be purchased with a small down payment and monthly payments. Travelers took the New York Central Railroad through Peekskill and then a taxi to Lake Peekskill. Clinton Acker of Peekskill invested the necessary funds to have Oscawana Lake Road paved from Oregon Corners to where Morrisey Drive is today. (Courtesy of Putnam Valley Historical Society.)

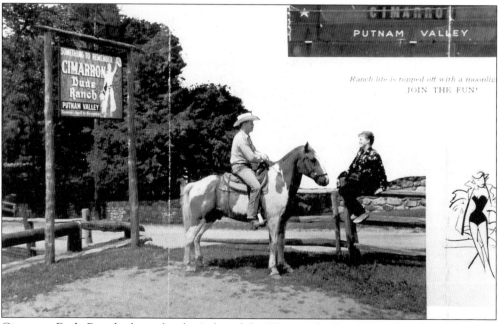

Cimarron Dude Ranch claimed to be "a bit of the West in the East." In its heyday, during the 1940s and 1950s, the popular resort catered to a clientele mostly from New York City. The ranch offered horseback riding, meals, and entertainment all for only $22.50 to $40 for a weekend. (Courtesy of Putnam Valley Historical Society.)

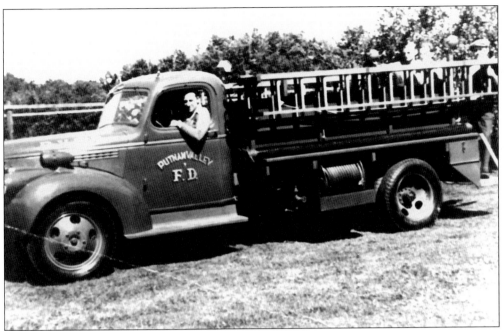

The first Putnam Valley fire engine is shown here in 1947. The vehicle was a navy surplus Darley pumper. The skilled driver is Art Perosky. The brave firemen on the back of the rig are Paul Schmittman, Charles Schneider, and Steve Gardineer. (Courtesy of Putnam Valley Historical Society.)

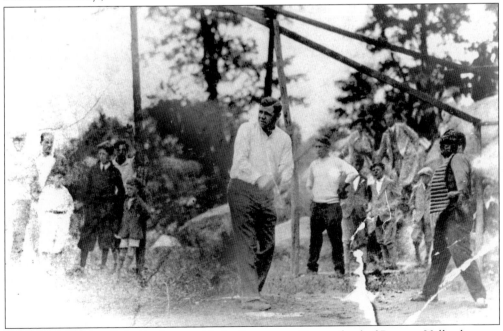

During Prohibition, Babe Ruth visited Lake Oscawana. He was fond of Putnam Valley because it was not a dry town. He rented a summer house in the area and was always interacting with the local residents. He is seen here playing ball with neighborhood children.(Courtesy of Putnam County Historian's Office.)

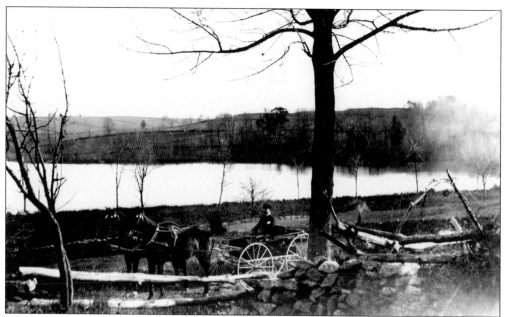

John T. Barger rides along Barger Road in 1897. Barger Pond is in the background. The Bargers came from Germany and were among the first settlers in Putnam Valley. Peter Barger or (Baragar) bought 213 acres of land from the commissioners of forfeitures in 1780. (Courtesy of Putnam Valley Historical Society.)

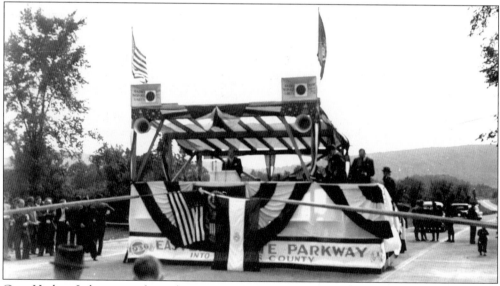

Gov. Herbert Lehman speaks at the opening of the Taconic Parkway through Putnam County on April 28, 1931. The parkway was built in two sections through Putnam Valley and Kent, and it was completed in 1938. The 42-foot-wide roadway provided a scenic route from New York City to points north. The road took advantage of the natural beauty of the region. Service stations and restaurants were built to blend with the parklike setting. The parkway was designed for recreational driving at a time when cars could barely reach a top speed of 55 miles per hour. The road was never intended to be the major commuter thoroughfare it is today. (Courtesy of Willitt C. Jewell.)

Six

PHILIPSTOWN

The only town in Putnam County to border the Hudson River, Philipstown truly lies in the midst of the Hudson Highlands. This area affords the most scenic and sweeping views of the mountains that bound either shore of the river. These steep and rocky mountains constitute the most elevated section of the highlands.

Founded in 1788, Philipstown was named for Adolphus Philipse, who owned the land that is the present-day Putnam County. The town was of particular importance because of its Hudson River shoreline. Before the railroad and the construction of Albany Post Road, the only route to New York City and Albany was the river. Farmers brought crops from surrounding areas via the Philipstown Turnpike (Route 301) to a place called Nelson's Landing to be loaded onto sloops and sent to New York City. The Nelsons owned the land in this vicinity, and they were among the town's more prominent inhabitants.

Harry Garrison acquired 105 acres and the river front landing in 1803. The area was then called Garrison's Landing. When the construction of the railroad was complete in 1849, the site was then referred to as Garrison's Station. Wealthy aristocrats rode the train from New York City to their country estates, built in this scenic region. A ferry to West Point was established here in 1829 by the Garrison family. By 1854, a steam ferry was in use, and this became a very important link to the western shore.

In 1855, the village of East Cold Spring was renamed Nelsonville in honor of the Nelson family. Several Nelsons held political positions within the town, and the family owned a mill on Indian Brook Road.

Cold Spring was incorporated as a village on April 22, 1846. Legend has it that during the 1700s, navigational charts list the site as a place where boats could fill their tanks with fresh pure water. Another theory states Gen. George Washington, while visiting American troops, drank at this spring at the bottom of what is now Upper Main Street, near the Hudson River, and referred to the place as Cold Spring.

The West Point Foundry Association was incorporated on April 15, 1818. After the War of 1812, it became evident that the nation would need foundries and machine shops capable of producing heavy cannons and artillery shells. Led by Gouverneur Kemble, the corporation acquired a tract of land at the southwest section of what became the village of Cold Spring. The site on the banks of the Hudson River was perfect. Waterpower was generated from Margaret Brook (today called Furnace Brook or Foundry Brook). There was iron ore available from mines in the area. Forests supplied fuel for heating the blast furnaces. Heavy guns and machinery could easily be shipped from here on the Hudson River. Skilled workers and mechanics secretly emigrated from Great Britain to work in the foundry. Apprenticeship programs were started in the United States. Clothing, housing, and board were provided by the corporation for the apprentices and workers. By the 1830s, a school and a Roman Catholic church, as well as stores, were established for these employees.

In 1836, Robert P. Parrott became associated with the West Point Foundry when he was commissioned as captain of the ordnance corps by the U.S. military. A year later, Parrott resigned his post and invested in the West Point Foundry Corporation. He developed the Parrott gun, which was the most effective piece of artillery during the Civil War. Parrott used a riffler to machine spiraled grooves into the cannon barrels, which made the projectile spin and thus gain greater accuracy and range. The success of the Parrott guns and the implementation of the West Point Foundry at Cold Spring were of great importance to the Union in the victory of the Civil War.

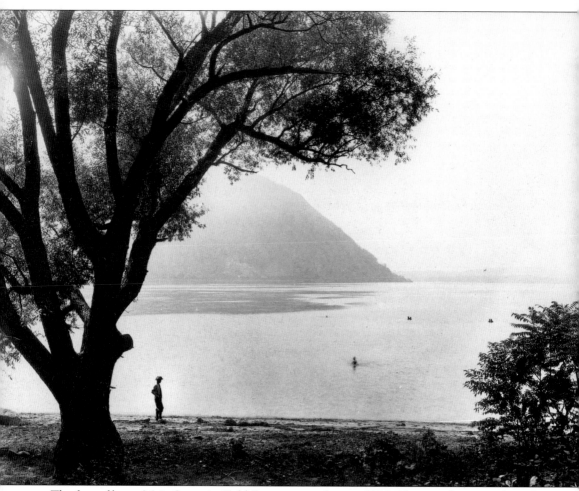

The foot of lower Main Street in Cold Spring is seen here *c*. 1900. The area shown is where the bandstand area is today. Storm King Mountain is visible on the far shore of the Hudson River. (Courtesy of Putnam County Historian's Office.)

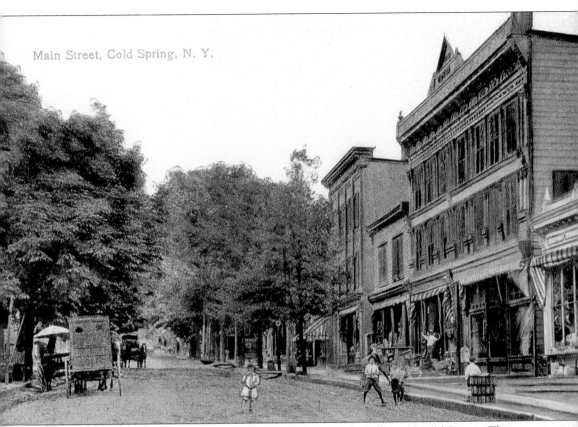

Main Street, Cold Spring, N. Y.

The Durand Building was one of two ironclad buildings in the village of Cold Spring. The two upper floors of this building were constructed of iron. The building is located on the south side of Main Street between Garden and Fair Streets. This is a view of Main Street in 1915. (Courtesy of Desmond Fish Library, Garrison, New York.)

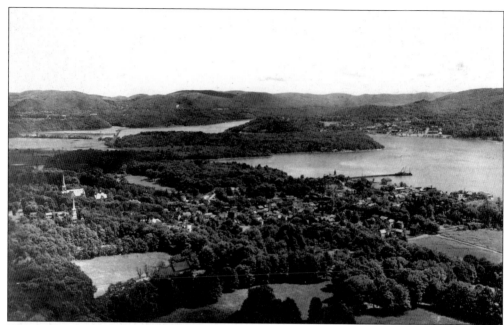

This bird's-eye view shows the village of Cold Spring *c.* 1900. The 600-foot-long West Point Foundry dock extends into the Hudson River. Boats were tied to the dock and would export products down river to New York City or north to the Erie Canal and points beyond. Constitution Island can be seen in the river, and West Point on the far shore. St. Mary's Episcopal Church is the top church on the left. (Courtesy of Putnam County Historian's Office.)

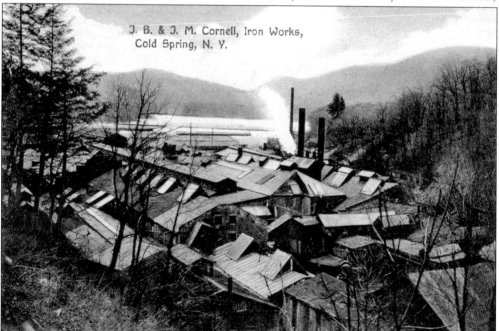

By 1898, the West Point Foundry was leased to the J. B. and J. M. Cornell Iron Works Company. The Cornells closed the factory in 1909, and by 1911, the site was abandoned. (Courtesy of Denis Castelli, the Taconic Postcard Club.)

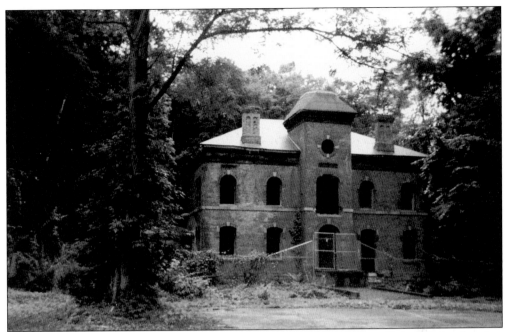

The administration building is the only structure from the West Point Foundry complex that still stands today. Built in 1865, this building is being restored through the efforts of the Putnam County Historical Society, Michigan Tech University, and Scenic Hudson Land Trust. It is hoped the building can serve as a visitor center amid the restored ruins of the foundry.

This is a replica of the famous Parrott gun invented by Robert P. Parrott. The cannon was built at the West Point Foundry and was first used at the Battle of Bull Run, during the Civil War. A unique feature of this cannon was an iron collar that was heated and shrunk around the rear of the gun barrel. This process strengthened the barrel and prevented it from exploding when the gun was fired. This model was built by blacksmith Norman Champlin as a gift to his nephew Jonathan, who donated it to the village.

The Philipstown Town Hall was built on upper Main Street in 1867. Since that year, the building has been in continuous use as government facility. The local jail was housed here in earlier times. (Courtesy of Donald Bruen.)

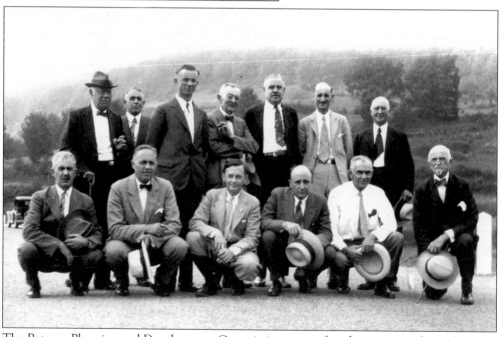

The Putnam Planning and Development Commission poses after the opening of a road project in 1931 at Mekeel's Corners (Routes 301 and 9). Only 200 miles of roadway were paved in Putnam County at the time. The National Recovery Act of 1933 allocated an astounding $95 million to improve secondary (or farm-to-market) roads. As early as the 1920s, Hamilton Fish II encouraged the formation of this committee, which was the forerunner of the Putnam County Planning Department. (Courtesy of Willitt C. Jewell.)

The ruins of the Canopus Mine are seen here in 1936. This was the last operating iron mine in Putnam County. It was located just southeast of the intersection of Canopus Hill and Old Albany Post Roads, near the area of Travis Corners. (Courtesy of Allison Albee.)

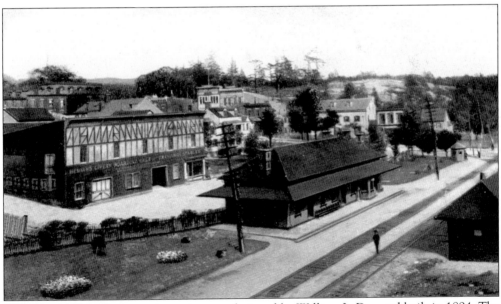

The original Cold Spring train station was designed by William LaDue and built in 1894. The large building behind the station was Henyan's Livery Stables. A new station was built in the 1990s, and the old building now serves as the Cold Spring Depot Restaurant. (Courtesy of David Bisbee, Taconic Postcard Club.)

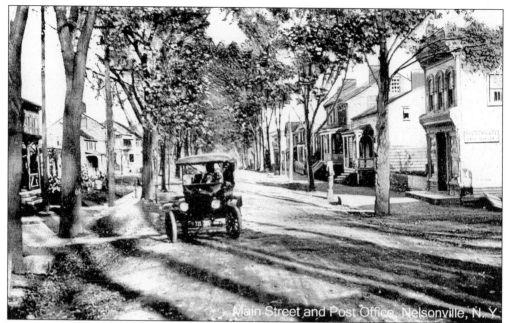

Main Street of Nelsonville is seen here c. 1910. The post office, which was established here in 1888, can be seen on the right. Edward Bodge's general store was also located in this building. (Courtesy of Desmond Fish Library.)

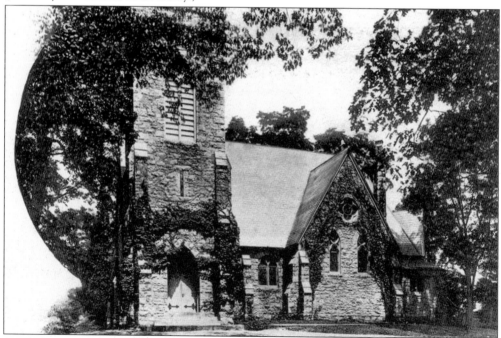

St. Philip's Church was designed by Richard Upjohn and built in 1863. The first church was a wood frame structure, built in 1771. During the Revolution, Gen. George Washington prevented it from being burned by drunken American soldiers bent on revenge. His words to these men were, "This is my church and we are not in this war to burn down churches." (Courtesy of David Bisbee, Taconic Postcard Club.)

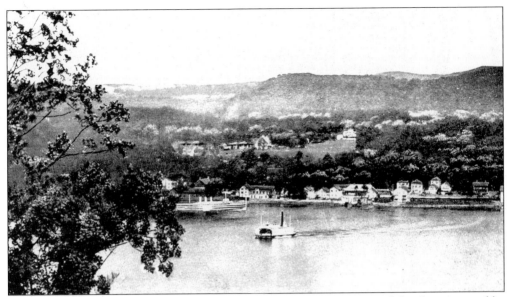

The ferry *Highlander* had a capacity of 13 horse-drawn wagons or automobiles. It was owned by the Garrison and West Point Ferry Company and ran between Garrison and West Point from 1878 to 1928. The *Highlander* sank in the slip at Garrison in 1928. The remains of the ferry and ferry slip can still be seen today. (Courtesy of David Bisbee, Taconic Postcard Club.)

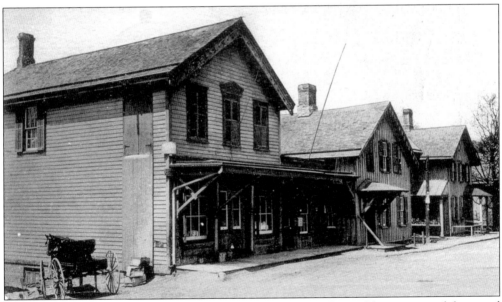

The Forson brothers opened this general store in 1898. They sold a variety of farm and household items, delivered feed and groceries to local customers, and published the first postcards of Garrison. They ran the store together until John Forson retired at the age of 90. James Forson continued running the store for 10 more years, until he retired in 1923. (Courtesy of David Bisbee, Taconic Postcard Club.)

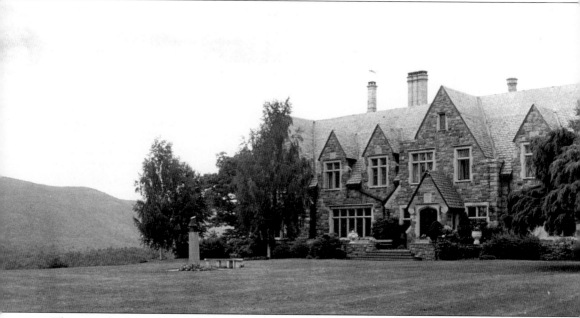

This was the home of Col. Jacob Rupert, owner of the Rupert Brewery and the New York Yankees. Jacob Rupert combined three separate properties to form his 360-acre river view estate, called Eagle's Rest. Two eagle statues from Grand Central's terminal are still on this property, located on Route 9D. Babe Ruth was said to have signed his most lucrative contract in this building. In 1944, the Greek Orthodox Archdiocese of North and South America bought the property and established St. Basil's Academy. The academy still serves as a home for children in need. (Courtesy of Jim Lukoszewski.)

Seven

PATTERSON

The town of Patterson is located in the northeast corner of the county. It was originally established as the town of Franklin, named after Benjamin Franklin, on March 17, 1795. In 1808, the name was changed to Paterson in honor of Matthew Paterson. Born in Scotland, Matthew Paterson came to this country in 1752. He was an officer in the French and Indian War serving under Gen. James Abercrombie. After the war, Paterson had business interests in New York City. He eventually came to live in Putnam County in 1770. He owned a farm for many years and became a prominent citizen, holding the offices of state legislator and justice of the peace. He was helpful in many ways to the government during the War of Independence. He is responsible for the many Scottish families who settled in this town from Massachusetts and Connecticut.

The name of the town was changed from Paterson to the present-day spelling in the mid-1800s to avoid being confused with Paterson, New Jersey. Eventually, small settlements were established in certain areas of the town. Cowl's Corner was at the intersection of what is now Route 22 and Haviland Hollow Road. Benjamin Cowl operated a tavern and a general store at this location with great success. The village of Towners, which was originally known as Four Corners, derives its name from James Towners who owned a public house at the location. "The City," or Patterson Village, was located at the present-day site of Routes 311 and 292.

The Great Swamp extends to both sides of the Croton River. In 1792 and again in the early 1800s, Matthew Paterson proposed a petition to drain the swamp and reclaim the fertile land for farming and pasture. Fortunately, this wonderful ecosystem still stands untouched today.

With the introduction of the railroads in the mid-1800s, the population of Patterson increased. Dairy farms emerged that produced milk for the now easily accessible New York City.

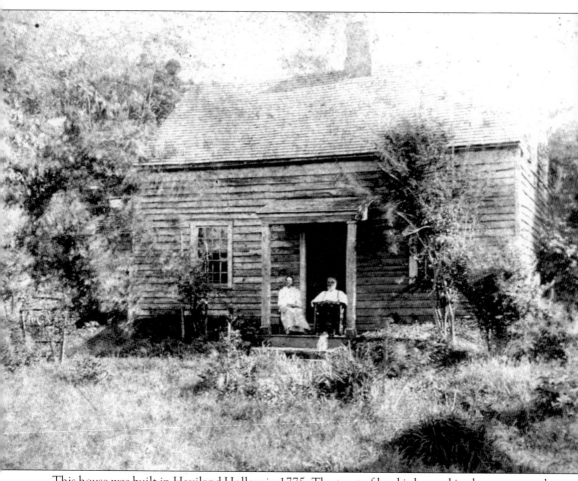

This house was built in Haviland Hollow in 1775. The tract of land is located in the east central region of Patterson. Benjamin Haviland was the first resident of the hollow. The Haviland family consisted of mostly farmers who owned much of the property in the area. (Courtesy of Putnam County Historian's Office.)

This photograph of the Penny farm was taken December 3, 1949. Patterson had a good amount of fertile farmland. Cattle and dairy farms were still abundant into the 1940s. John Penny's farm was on Route 164 near the Old Patterson Town Hall. (Courtesy of Frank B. Light.)

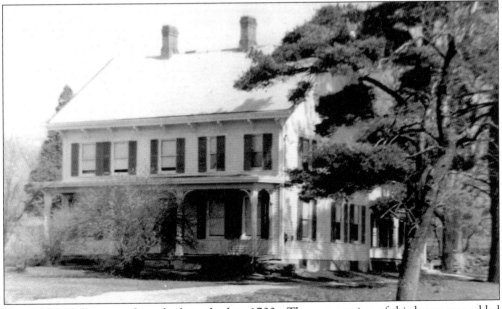

The Old Peck homestead was built in the late 1700s. The rear portion of this house was added c. 1840. A unique feature of this house is the huge fireplace located below grade in the basement. This house stands near the old Mulberry Freight Line Railroad overpass on Route 311. The line hauled freight from Danbury, Connecticut, to Poughkeepsie. During World War I, a train wreck and explosion occurred here and blew out the windows of this house. The train was carrying marbles, and they were scattered around the countryside for miles. (Courtesy of Floyd Fisher.)

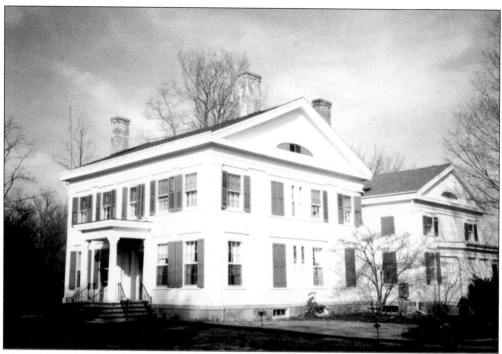

The oldest section of this house was built by Matthew Paterson *c.* 1780. His grandson Matthew C. Paterson added on to the existing structure in 1843. He used Greek Revival design, popular in the mid-1800s. Matthew C. Patterson served as a judge and held several elected positions. The house still stands today on Route 311 at Cornwell Hill Road. (Courtesy of Tom Keasbey.)

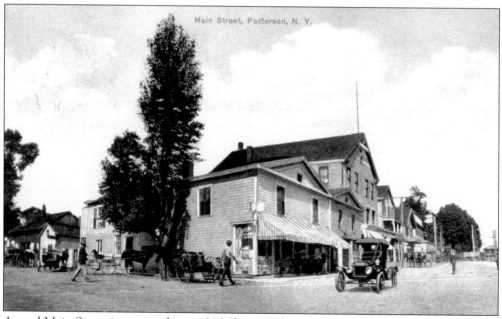

A rural Main Street is seen in this *c.* 1916 photograph. (Courtesy of Denis Castelli.)

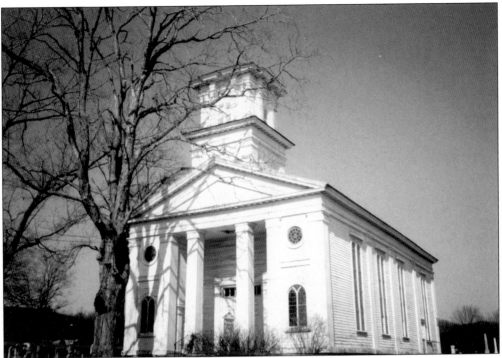

The Patterson Presbyterian Congregation was organized in 1775. The original church stood just west of the present structure. The church seen here was built in 1836 and expanded in 1867. This Greek Revival–style structure has massive squared pillars and a square tiered bell tower. Sybil Ludington attended services at the original church and was married there in 1784. (Courtesy of Donald Bruen.)

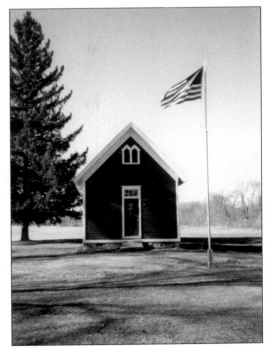

The Patterson Historical Society's museum is housed in this schoolhouse, which was built at the beginning of the 19th century. It was moved from Aikin's Corners on Route 22 to South Street. (Courtesy of Thomas Keasbey.)

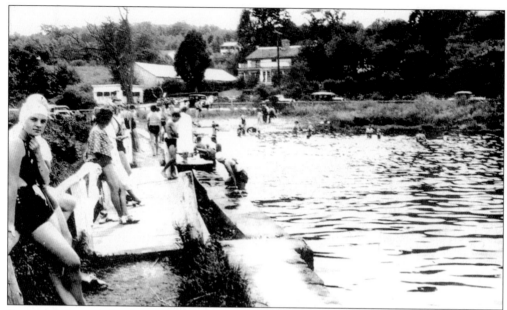

Putnam Lake was developed by the Smadbeck brothers, starting in 1931. Two-lot building parcels were offered for $95 by the brothers' company, the New York *Daily Mirror* Holding Company. No utilities were provided, and each plot included a hand-dug well and an outhouse. Kerosene fuel was used for light. The cottages were for summer use only, and after Labor Day the lake was deserted. The structures have now been winterized and are used year-round.

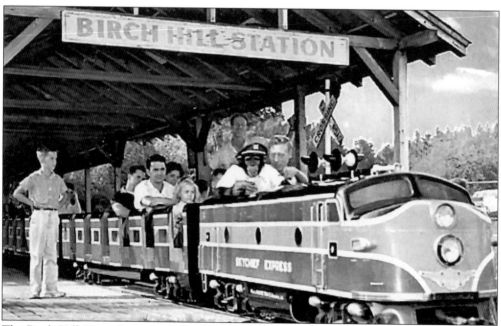

The Birch Hill Game Farm was a popular tourist attraction in Patterson in the 1960s and early 1970s. The farm was situated where Thunder Ridge Ski area is today. A miniature railroad wound its way up the mountain. A petting zoo and a variety of animals were on display. (Courtesy of Southeast Museum.)

The village of Patterson was an important destination for farmers. The Patterson Farm Service (in the white building) sold and repaired farm machinery. The store also sold feed, paint, and hardware products, as seen in this 1940s photograph. (Courtesy of Frank B. Light.)

Tanks and half-tracks were transported by railroad during World War II. Military vehicles were shipped from Detroit to Brewster Junction and transferred to the Putnam line to be taken to New York City and shipped overseas. The Putnam line was able to handle oversized freight due to the absence of clearance restrictions. This train is paused at the Patterson Railroad station of the Harlem Division. (Courtesy of Frank B. Light.)

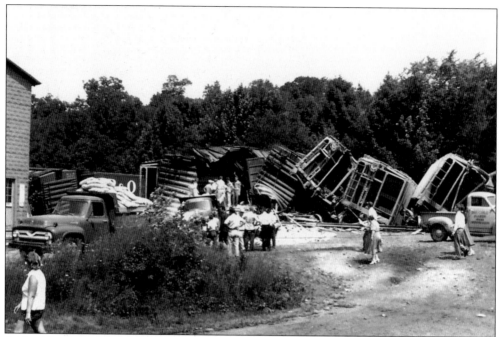

Although rail travel was considered safe and reliable, it was not without an occasional mishap. This train wreck occurred at the Patterson station in the 1940s. A wreck can be caused by several factors such as human error, track malfunction, or debris on the track. (Courtesy of Frank B. Light.)

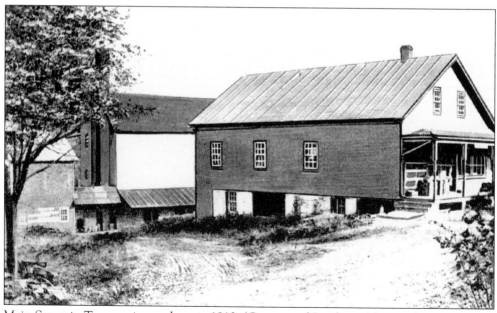

Main Street in Towners is seen here in 1910. (Courtesy of Southeast Museum.)